James McNeill Whistler

Lithographs

From the Collection of Steven Block

Trust for Museum Exhibitions
Washington, D.C.

Published in 2000 by the Trust for Museum Exhibitions
1424 16th Street N. W., Suite 600
Washington, D. C. 20036

ISBN: 1-882507-09-6
10 9 8 7 6 5 4 3 2 1

Catalogue and cover designed by Melissa Anne Allen
410.662.7879 email: hugs@erols.com

Printed by Schneidereith & Sons, Inc. Baltimore, MD.
Text: Mohawk Vellum, cream white
Cover: Sappi Lustro, dull enamel

Butterfly (detail), pages 1, 21, 31, 43, 51, 63, 75, and 87: Whistler's inscription to Charles L. Freer, 1896.

Photography Credits:

Page 3: Lithographic portrait of Whistler by T. R. Way, possibly intended as a frontispiece for Way's catalogue,
Mr. Whistler's Lithographs, 1896.

Page 5: The Ethel Birnie Philip–Charles Whibley Wedding Party, garden of 110 rue du Bac, Paris, 1894.
The newlyweds are at right, next to Whistler. University of Glascow

Page 7 and page 18, upper left: James McNeill Whistler, c. 1892. National Monuments Record, London

Page 10: James McNeill Whistler in his Paris studio on rue Notre-Dames-des-Champ (detail),
c. 1892–94. Freer Gallery of Art

Page 18, upper right: Peacock Room (detail). Freer Gallery of Art; lower: *Whistler's Mother.* Freer Gallery of Art

Page 19, upper left: Beatrix Birnie Philip at age eighteen (detail). University of Glasgow; upper right: Lithographic
portrait of James McNeill Whistler by T. R. Way, c. 1900. The National Portrait Gallery; lower right: Rosalind Birnie
Philip (detail), c. 1895. University of Glasgow

Front cover: James McNeill Whistler (detail), c. 1892. National Monuments Record, London; Butterfly, Whistler's
inscription to Charles L. Freer, 1896.

Back cover: *The Yellow House, Lannion,* 1893, 9 3/4 x 6 1/2 inches

Front inside cover: *Draped Figure Reclining,* 1890–1893, 7 x 10 3/8 inches

Back inside cover: *Lady and Child,* 1890–1893, 5 7/8 x 8 7/8 inches

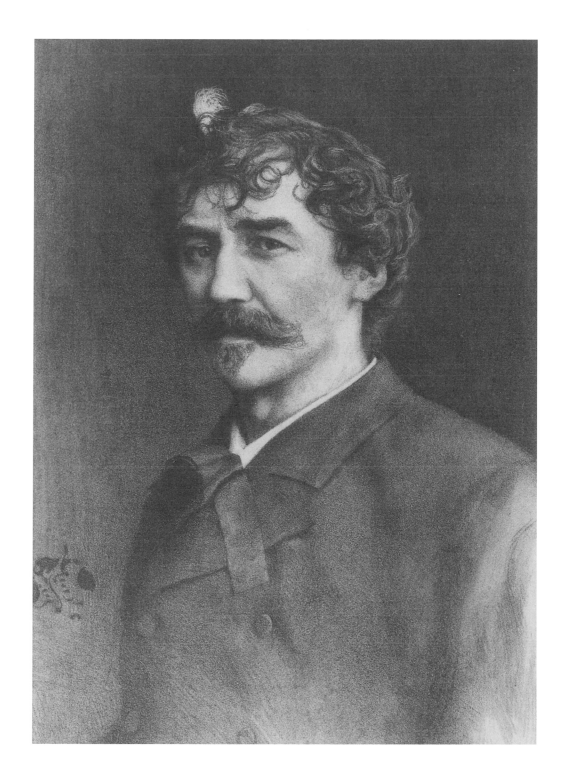

Acknowledgments

For a very long time I have known the unequalled collection of Whistler lithographs belonging to Washington, D.C. art collector Steven Block. To me, these exquisite works are the finest examples of black and white and color lithography I have been privileged to see. In appearance, more like exquisitely fine chalk, crayon and wash drawings of extraordinary delicacy, they are truly "songs in stone."

It is difficult to know how to thank Steven Block adequately for his amazing generosity, his patience, his good cheer and his flexibility. Everyone at the Trust for Museum Exhibitions bears great affection for Steven, and considers him in a real sense an extension of staff to whom we are very grateful.

We also owe special appreciation to the long, hard work of our exhibition staff members, especially Diane Salisbury and Katalin Banlaki, who saw the entire project through from beginning to end with care, devotion and good humor.

We are also grateful to Melissa Allen for her elegant catalogue design, to Nesta Spink and Steven Block for their equally elegant text. Last but not least, we would like to express our appreciation to Kathleen Tanham for her invaluable assistance with the catalogue preparation and to Michael Feeney of Schneidereith & Sons for the printing of the catalogue.

Ann Van Devanter Townsend
President, Trust for Museum Exhibitions

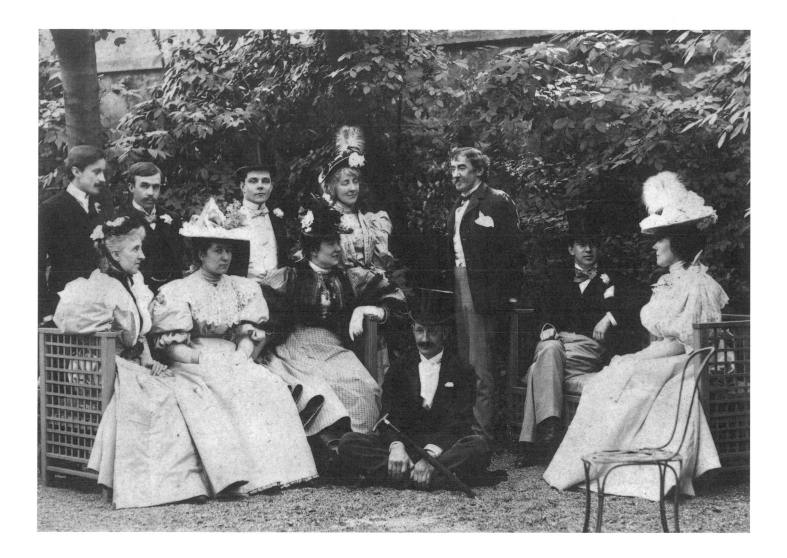

A Collector's Note

". . . it is clear that in lithography the master has found a medium which is more sympathetic and personal even than the copperplate."
—Thomas R. Way,
Mr. Whistler's Lithographs,
The Catalogue, 1896.

James McNeill Whistler was a leading figure in the revival of lithography in the late 19th century. His eccentricities are well known and fascinating. However, it was his lithographs' gentle and understated quality, along with a remarkable bent for experimentation, which attracted me.

From my first exposure in 1978, I was drawn to them. I knew of Whistler's graphic skill through his better-known etchings, but his lithographs were a special discovery. *La Belle Dame Endormie* and *La Robe Rouge,* two portraits of his wife drawn when she was showing the first signs of her fatal illness, were my introduction. They immediately affected me and still do.

Earlier, I preferred the prints of such artists as John Sloan and Reginald Marsh, who explored social themes in their work. Whistler, by contrast, was a proponent of art for art's sake believing that "art should stand alone" and be "independent of devotion, pity, love, patriotism and the like," as stated in his *The Gentle Art of Making Enemies.* As I became familiar with his lithography, produced late in his career, and the extensive correspondence related to it, this new medium he chose to adopt seemed perfectly suited to the quick sketch as well as the capture of atmosphere and mood. The qualities expressed in his lithographs were in sharp contrast to Whistler's personal elitism. When I saw his late lithotint, *The Thames,* and gradually became familiar with other lithographs, I responded to his inventiveness and felt the richness and depth in the effects—in the water, mist, and fog of the river—in the drapes of clothing when he used the techniques of "stumping" —in the flickering firelight of his portraits. I was moved by the tenderness with which he depicted both daily scenes and the people particularly close to him. The shops and shopkeepers, smithies, studio models, family and friends were drawn from daily life and transformed by his sensibility—lyrical, subtle, and unique.

Whistler's lithographs focus upon scenes and themes earlier explored in his paintings, etchings, and pastels. Using transfer paper, he created the effects of drawing. With a few lines he was able to convey a total picture, in part, by a technique he called "vignetting." Whistler once explained this technique to his protegés: he started sketching at the point of chief interest, and then worked outward, stopping at any point and still having a "fine and complete" picture.

The lithographs are more than surface arrangements. Thinly disguised beneath the veil, half-hidden by the shadow and the firelight, are revelations—glimpses of a world in which Whistler delighted. The lithographs transfix the moment. They evoke mood; simultaneously they suggest elegance and intimacy.

.

I am delighted to share this collection of Whistler's lithographs with the public. Over the last two decades, it has been an honor to participate in the study and renewed appreciation of the lithographs and their significance in Whistler's legacy. I am especially grateful to Nesta Spink for once again contributing to this appreciation by writing the essay and assisting with the technical

work for the exhibition catalogue. Faye Harbottle gave special support in compiling and editing the material.

I wish to thank Nigel Thorp of the Center for Whistler Studies, University of Glasgow, Scotland, and Martha Tedeschi, Curator of Prints and Drawings at the Art Institute of Chicago, for involving me in the Chicago forum that accompanied the release of the definitive catalogue raisonné of Whistler's lithographs in 1998. Elizabeth Hutton Turner, Curator at the Phillips Collection in Washington, D.C., has given me a fresh historical perspective regarding the influence of Whistler on the creative processes of 20th–century American printmakers and photographers.

This exhibition is prefigured by events that occurred between 1978 and 1982. For their tireless efforts in those years I wish to acknowledge Susan Hobbs (then with the National Museum of American Art) and Nesta Spink. They assisted me personally and created the catalogue for the 1982–85 Smithsonian (SITES) tour, which was, at that time, the most comprehensive, focused exhibition of Whistler's lithographs in sixty years. Earlier, my principal art dealer, Jem Hom, and the staff of the Freer Gallery of Art Library and Print Room, assisted me in learning about the lithographs. Sara Gamble Epstein, a fellow collector and custodian of the largest private collection of the works of Edvard Munch, provided constant encouragement and support. Above all, my thanks go to Paddy Shannon Cook, who helped form the basic concept for the 1982 exhibition; that concept dominates this current expanded exhibit as well. We shared many insights as we read through materials and correspondence––often unpublished––and came to recognize the real value of these lithographs.

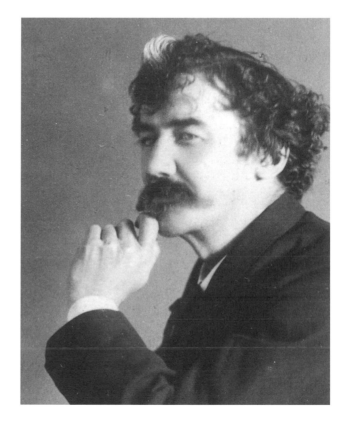

Steven Block

CATALOGUE

11

INTRODUCTION

12

TECHNICAL NOTES

16

CHRONOLOGY

18

LITHOGRAPHS

BIBLIOGRAPHY

94

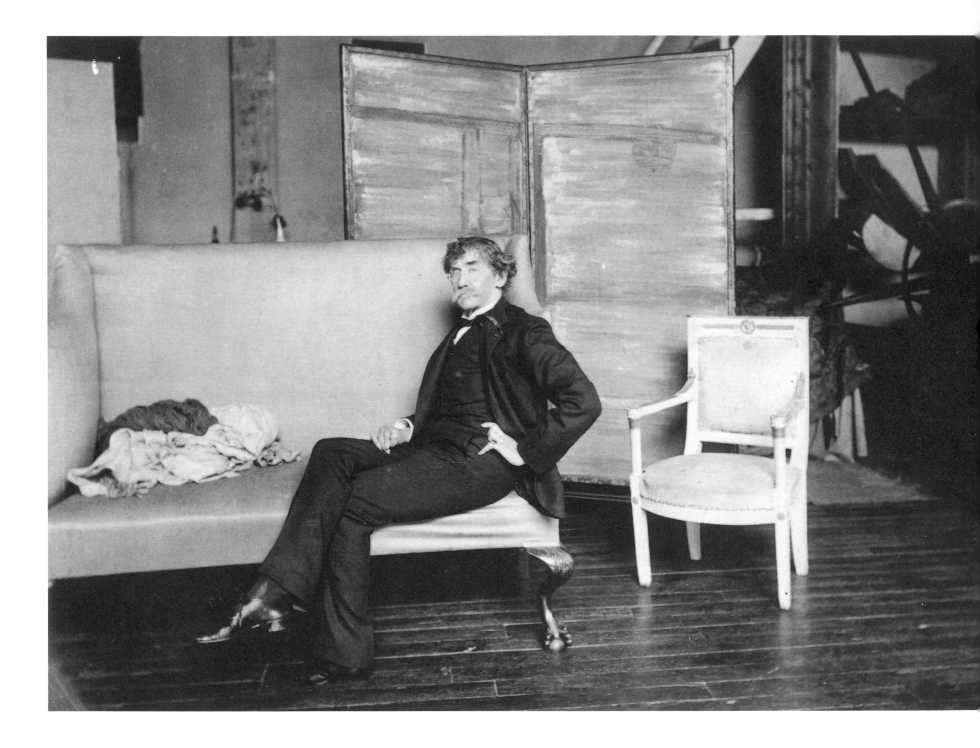

The Catalogue

An Introduction . . .

Nesta R. Spink

The last two decades have seen a resurgence of interest in James McNeill Whistler's lithographs. Steven Block, who was one of the first to see the logic of the revival, and to respond to the lithographs' unique qualities, began assembling an important collection in the late 1970s. His collection circulated in the early 1980s under the auspices of the Smithsonian Institution and has grown since that time. Meanwhile the lithographs have attracted increased attention among public and private collectors. A long-awaited revision of T.R. Way's 1905 catalogue raisonné was published in 1998 by the Art Institute of Chicago—an event heralded by a major exhibition of the lithographs and related works. Whistler often referred to his lithographs as "Songs on Stone." At last, these understated works are receiving the acclaim they deserve.

When Whistler began his work in lithography in 1878 with Thomas Way, the respected London printer and father of T.R. Way, both his finances and reputation were in serious disarray. He had quarreled with his patron, Frederick Leyland, over the Peacock Room decoration and had brought his infamous libel suit against John Ruskin, the leading art critic of the day. And it was not an auspicious moment to explore the artistic potential of lithography. Although the medium had attracted many artists in France and Britain soon after its late 18th–century invention in Germany, lithography had suffered a long decline, becoming merely a commercial enterprise for the production of advertising materials, inexpensive illustrations and ephemeral, cheap machine-printed reproductions and chromolithographs for the growing middle class.

By the 1850s and 1860s, it was disparaged and ignored by artists and critics alike. Thomas Way appears to have been the only printer in Britain in the 1870s with a commitment to promoting original work in lithography. Way was seriously interested in the fine arts and undoubtedly weary of much of his commercial printing business. Whistler, in turn, was at a low point in his career and happy to launch a new project in the hope of extending the range of his work and attracting a wider audience. Picturesque etchings in his "French Set" and his realistic topographical etchings produced in England in the late 1850s and early 1860s were popular, but the increasingly reductive, atmospheric aesthetic of his more recent prints and paintings seemed puzzling and inconsequential to his public. The nuanced, poetic world of his "nocturnes" and "harmonies" was completely alien to Victorian sensibility which expected art to tell a story, be morally uplifting, and record the natural world in minute detail.

Both Whistler and Thomas Way were aware of the revival of interest in original lithography stirring among artists across the channel. Corot, Manet, Fantin, Degas and Pisarro had been exploring the medium in Paris: the printer and the painter in London were optimistic about initiating a similar renascence in Britain.

More than two decades earlier, before he left America to study in Paris, Whistler had executed two lithographs; however, in 1878 he cannot have been familiar with technical aspects of the medium. Way's instruction must have been excellent; Whistler responded with his usual sensitivity to the inherent possibilities of working on stone with crayon and "tusche" washes. (T.R. Way describes how his father, in order to enable Whistler to work from nature, supplied "barges, barrows and porters" to get a stone to Limehouse and sat beside Whistler while he worked on his first

Thames lithotint.) Whistler's success with the lithotint process was so complete that Way was forever afterwards trying to encourage him to return to the medium.

After making a few experimental images exploring various techniques, he soon created six lithotints that are among his finest works in any medium. Four of the lithotints were commissioned by the editor of a fledgling periodical, *Piccadilly*, in the vain hope that their inclusion would increase circulation. Then, Thomas Way attempted to launch a scheme to issue a number of Whistler's images on stone and transfer paper to be sold by subscription. That effort failed dismally as well. The small, understated prints were either overlooked or mistaken for reproductions. Whistler had hoped that his experimental lithotints rendered in ink washes on stone would encourage appreciation of his large oils that had been met with critical derision. However, the few figure studies and London views he drew on transfer paper were probably not seen beyond the Way offices after trial proofs were pulled. Bankrupt and discouraged after producing seventeen lithographs that received scant attention, Whistler set off for Venice in the autumn of 1879 with a commission from the Fine Art Society of London to execute a series of etchings of the legendary city. The trip resulted in a long hiatus in his work in lithography but there is reason to surmise that his experience using ink washes on stone may have provided the impetus for the evocative tonal wiping employed in his highly personal printing of the Venetian etchings.

Whistler did not resume work in lithography until 1887. By that time, the revival in France was in full swing and had begun to reawaken interest in Britain. In March 1887, an exhibition of his etchings at the Hogarth Club included one of his lithographs, which attracted favorable notice in the press. Later that year, six images he and Way had hoped to sell to subscribers in 1878 were issued in a portfolio, entitled *Notes,* by the London branch of Boussod, Valadon, and Co. They now found a more receptive audience. Thirty sets mounted on large sheets and signed in pencil sold quickly; seventy sets on smaller mounting sheets, unsigned, and missing the *Limehouse* were less popular. The moderate success of *Notes,* as well as critical evidence of increasing interest in original lithographs, encouraged Whistler to continue his work in the medium.

In the summer of 1888, he married Beatrix Philip Godwin, widow of his architect-friend, E.W. Godwin. Beatrix (or "Trixie") was an amateur artist who seems to have taken particular pleasure in his lithographs, perhaps because she was present when many of his drawings were made on the sheets of transfer paper he carried with him in their travels and while exploring the neighborhoods near their homes. Lithography became his major printmaking endeavor for almost eight years following his marriage—the happy and productive years before Trixie's untimely death. Working in lithography and blessed by the extraordinarily obliging collaboration of Thomas Way and his son, T.R. Way, Whistler was freed from the labor of doing his own printing, a task that had become burdensome over the years as he struggled to complete his painstaking printing of the Venetian etchings. Drawing "quick notes in passing" on transfer paper allowed Whistler to seize the moment and spontaneously record the essence of his subject—whether this was a shopfront in Chelsea, the seated figure of a friend or a young model moving about in his studio.

Whistler made a single experiment in color lithography with Thomas Way in 1890 but continued his work with a more experienced color printer, Henry Belfond, in Paris. Ultimately, he produced six additional color images with Belfond before their association came to an end. The finest of these rare color prints resemble drawings touched with pastel or watercolor; fortunately, three very fine color proofs are included in the Steven Block Collection.

During the early 1890s, Whistler began to spend increasing amounts of time in Paris, in part because he was crossing the channel to work on portrait commissions, in part because he found the Parisian world of art and letters far more stimulating and congenial than London's. He became an intimate in Mallarmé's literary circle, renewed old friendships and made new acquaintances in the French art world. Late in 1891, Whistler's portrait of his mother was purchased by the Musée du Luxembourg and in January 1892 the expatriate American was made an Officier of the Légion d'Honneur. Some months later, the Whistlers left London, and moved to a home in Paris near the Luxembourg Gardens. The years that followed were pleasant and creative. He worked on a variety of transfer papers making drawings of streets, shopfronts, public buildings, and his favorite pathways in the Luxembourg gardens. He made portraits of family and friends—often in the sitting room or garden of the house on rue du Bac—in sunlight or evening shadow—and produced an occasional portrait on commission. When he and Trixie traveled through Brittany in the summer of 1893, Whistler made an important series of transfer drawings, and he continued to work with young models whom he hired to pose in the Paris studio. The majority of the transfer drawings were sent off to the Ways in London but a few were transferred by Parisian printers. He searched constantly for improved transfer papers and hunted for supplies of antique or "beautiful Japanese" papers to send the Ways for printing his finest proofs.

Sadly, this halcyon period came to an end when Beatrix Whistler became ill. On the advice of Whistler's brother, William, a physician who had settled in England, the couple returned to London. They remained in London for a time, then went to Lyme Regis in Dorset hoping that the sea air might prove beneficial. In the fall of 1895, Trixie's condition worsened, and they returned to London. As they moved about, Whistler—though distracted—continued his work in lithography and kept the Ways busy processing new drawings. The couple moved into the Savoy Hotel as Trixie's cancer continued its relentless course. During this final phase of her illness, Whistler stayed by her bedside and executed a series of memorable lithographs that surely brought her happiness. When the first proofs came back from Way's office, they must have given the Whistlers real moments of shared pleasure.

Whistler drew a series of images on transfer paper looking down and across the Thames from the windows of the hotel and also found time to execute another lithotint with inks and a stone prepared by the Ways. In spite of initial problems with the preparation of the stone, Whistler made repeated corrections and finally was able to achieve the effect he sought. Although he had not worked in wash on stone in almost two decades, *The Thames* is an unforgettably poetic print. He drew two tender transfer lithographs of Beatrix as she lay in her bed near the balcony of the Savoy. These poignant images were created close to the end of Whistler's long collaboration with the Ways. Only weeks after

Trixie's death in May 1896, their friendship was terminated acrimoniously. Although Whistler produced several more lithographs that were printed by Lemercier and Clot in Paris, none has the evocative nuance of the late works printed in London. After Whistler's death, a few additional images were printed for the first time, when Frederick Goulding's firm was commissioned by Rosalind Birnie-Philip, Whistler's sister-in-law and executrix, to pull posthumous editions of stones retrieved from the Ways.

The extraordinary correspondence between Whistler and the Ways spanned several decades. The artist's letters accompanied transfer drawings mailed to London from Paris, Brittany, or Dorset and contained questions, comments and instructions. The Ways' letters were included with the proofs they sent back. This long correspondence illustrated their mutual respect and admiration that lasted until the abrupt end of their friendship. The letters provide an exceptional opportunity to learn about Whistler's thinking, his attitudes toward dealers, the marketplace, contemporary critics and countless other topics. They bear witness to Whistler's expectation of fame from his lithographs and his bitter disappointment when the prints were overlooked. Above all, we recognize his incredible attention to detail. He was concerned about such matters as the color and texture of the papers on which the proofs were printed, about the size of the sheets and the location of impressions on the sheets, or about making small alterations in an image when he returned to London and could make changes in the stone himself. Constantly he warned the Ways to keep lithographs needing correction or those deemed unsuccessful hidden from view. In turn, the letters of Thomas Way and his son testify to their esteem for Whistler (near veneration) as well as their patience and willingness to go to

amazing lengths to attend to the smallest details that meant so much to him. Finally, the letters bear witness to the mutual dependence, intensity and excitement that characterized their collaboration.

Whistler regarded his lithographs as an extension of the art of drawing. He wanted the quiet, understated images (generally printed in very limited editions) to be collected and cherished like "the most delicate drawings out of a Museum." When he learned that his lithographs would neither attract a mass audience nor relieve his financial insecurity, he determined instead to market them to connoisseurs as precious objects of enduring value. In reality, his small "Songs on Stone" have frequently been over-looked when surrounded by more brilliant or commanding prints. However, they are the most spontaneous and intimate expression of Whistler's art—works of "happy inspiration" and reductive aesthetic vision. They demand that we adjust our eyes and minds to their scale and nuance. They are never made static by over-elaboration; rather, they suggest more than is recorded and thereby invite a perceptual dialogue between the viewer and the subject captured fleetingly by the artist. The appeal of Whistler's lithographs will be as strong today as it was a century ago for those who pause to study them with care, and experience their poetic revelations.

Technical Notes

The catalogue is organized thematically under seven subject headings. Dimensions are in inches with height preceding width, and refer to the measurement of the image. Dimensions, dates, and titles are derived from the published catalogue raisonnés of Whistler's lithographs.

ABBREVIATIONS

WAY (W. followed by a numeral). Catalogue number from T.R. Way, *Mr. Whistler's Lithographs* (1896 and 1905). T.R. Way was the son of Thomas Way, who introduced Whistler to lithography. T.R. Way catalogued Whistler's lithographs and later wrote *Memories of James McNeill Whistler*, a biography (1912). He followed his father into printing; the firm was known as Thomas Way and Son.

LEVY (L. followed by a numeral). Catalogue number from Mervyn Levy, *Whistler Lithographs, an Illustrated Catalogue Raisonné* (1975). Although this publication has had limited use and is not considered very reliable, the numbering system included more works than the T.R. Way catalogue. It provided the only other method to identify lithographs until the Chicago Art Institute publication of 1998. It is still used by many libraries.

ART INSTITUTE OF CHICAGO (C. followed by a numeral). Catalogue Number from *Lithographs of James McNeill Whistler, A Catalogue Raisonné* (1998). This publication from the Art Institute of Chicago, resulting from a decade of study and research, uses this latest and most comprehensive cataloguing system. It is now officially acknowledged by the Library of Congress. (Developed by Nesta Spink, principal researcher, with Harriet Sratis and Martha Tedeschi, general editors for the project.)

 The collector's marks cited by F. Lugt, *Les marques de collections de dessins et d'estampes* for Rosalind Birnie Philip (also known as Birnie Philip), Whistler's executrix and sister-in-law. His numbers for other collectors are also cited. Birnie Philip's initials in a square signify a lifetime impression she inherited while those in a circle denote a posthumous printing.

WAY EDITION: Way's record of the proofs pulled by his firm. Some editions are actually larger than he indicated.

PRINTED BY GOULDING: Subject previously known to have been printed posthumously by the firm of Goulding. (An asterisk indicates an impression in the present exhibition known to have been printed by Goulding.)

 SIGNED IN PENCIL (the butterfly): Whistler signed his lithographs and other works of art with a butterfly—a unique cipher derived from his superimposed initials. In every case Whistler's distinctive signature is placed with great attention to the overall design of the lithograph which is signed in the stone. A number of them are also signed in pencil.

PRINTING FOR PERIODICALS: Lithographs were transferred to several stones for editions exceeding one hundred impressions in order to preserve the original stone. According to Way they were run off by machine, perhaps in as many as three thousand impressions (Way to Whistler, July 15, 1895, BP II 33/40, GUL).

PROOF EDITIONS: Although Whistler mentioned limiting hand-pulled proofs to one hundred, in fact the majority of the editions printed by the Ways were relatively small. Many of the proofs were actually printed by the Ways' chief printer, H. Bray.

PAPER: Whistler's letters reveal his obsession with fine antique paper that he himself collected and sent to his printers. The Goulding

posthumous prints were also pulled on old paper, probably from Whistler's estate.

PARIS PRINTINGS: Most of Whistler's printings in Paris were carried out by the house of Lemercier, although at least one lithograph was produced by Auguste Clot. Belfond cooperated with Whistler in the color printing. Birnie Philip's ledger indicates that Goulding actually printed a number of lithographs previously listed as printed in Paris.

POSTHUMOUS PRINTING: Three months after Whistler's death, Frederick Goulding's firm began reprinting his lithographs. The arrangements were made with such dispatch that it can be assumed that some of the planning was done by Whistler and Birnie Philip, prior to his death. The printing was carried out by A. Smith of Messrs. Goulding, under her supervision. In a letter dated October 17, 1903, she wrote Charles Freer that the printing would be a secret and that she alone would be present. This secrecy was maintained until her death in 1958. In recent years, complete documentation of the posthumous printing has been released by the Whistler archives at the University of Glasgow, and appears in the 1998 Catalogue Raisonné published by the Art Institute of Chicago.

T.R. Way had listed 55 posthumous impressions, made before the stones were destroyed. These were recorded in Birnie Philip's ledger. However, a number of others were not included, such as the "untried drawings," several of which are part of the Steven Block collection. These were drawings left by Whistler on stone but not previously printed. There were also "untried transfers," which were drawings on paper not yet put on stone until posthumous printing was begun. Charles Freer urged that Goulding's edition be of no less than 50, but the total pulled by Goulding from a given stone was usually far fewer; both he and Birnie Philip were perfectionists, and were determined not to work with imperfect stones. After the Goulding editions were completed, the stones were destroyed except for eight which were given to the University of Glasgow, and are still maintained in the Whistler Archives.

COLOR PRINTING: Whistler first made a keystone drawing of his subject which was printed in black. According to Way's catalogue (1905), "then further drawings [were] made either on transfer papers or stones, one for each color to be printed." After scraping away the areas not to be colored, Whistler had the drawings transferred to stones. Proper registration for printing was achieved by the registration marks in the center of each side of the image. "Each tint [was] so placed that it fell in its right position on the proof," Way explained. Whistler worked closely with his printer, mixing colors and experimenting with various combinations on several stones. Few impressions of his color lithographs are identical; papers, colors, and their placement on the several stones required for a given image change from proof to proof. Apparently Whistler's color experiments ended by late 1893, even before the Belfond firm (who had printed at least four color subjects for him) had broken up. As none of Whistler's color printing went beyond the proof stage, despite the fact that William Heinemann had advertised their publication as "Songs on Stone," they are great rarities. The three exceptional color impressions in the Block collection which were printed by Belfond are examples of the heights that Whistler was able to achieve.

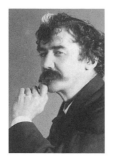

Moves to Chelsea district
of London with Jo Hiffernan,
his mistress and model.

Exhibits the famous *Falling
Rocket Nocturne* that leads to
the Ruskin trial. Decorates
the dinning room, known as
the Peacock Room, now
housed in the Freer Gallery,
Washington, D.C.

1860

Delivers the "Ten O'Clock"
lecture that defines and defends
his philosophy of aesthetics.

Born July 11 in
Lowell, Massachusetts.

Uses first dated
butterfly signature.

1834

1869

1876-1877

1885

1851-1855

After an unsatisfactory
stint at West Point and the
U.S. Coast Guard Geodetic
Survey, where he learns
etching technique, becomes
an art student in London.
Lives with his half sister, and
her husband, the etcher,
Seymour Haden.

1880

Produces a series of 12
etchings in Venice on a com-
mission awarded by the
Fine Art Society of London.

1870-1871

Publishes "Thames Set" etchings.
Paints the portrait of his mother.

1878-1879

Experiments for the first
time with lithographs and
lithotints under tutalege
of his printer friend Thomas
Way. Escalating money
problems and the Ruskin trial
lead to bankruptcy.

1887

Renews enthusiasm for
lithography and, with Thomas
Way, publishes 6 works
from 1878–79 in an edition
called *Art Notes*. Whistler
enters his new phase of lithog-
raphy, drawing subjects from
life, using transfer paper.

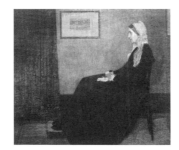

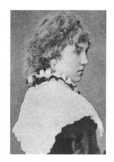

Newspapers proclaim, "Butterfly Chained at Last" upon, marriage to his architect's widow, Beatrix.

1888

Sells portrait of *Carlyle* to the corporation of Glasgow and the *Mother* painting to the French government. Continues to work in color lithography in Paris with M. Henry Belfond.

1891

Exhibition of works at the Goupil gallery a huge success, restoring public reputation and renewing financial patronage. Moves to Paris with Beatrix and rents a studio overlooking the Luxembourg Gardens.

1892

Whistler paints and produces many transfer drawings for lithographs processed by the Ways. In December a major exhibition of 75 of the artist's lithographs held at the Fine Art Society.

1895

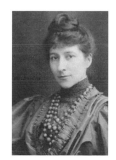

Resides at the Savoy Hotel where Beatrix dies of cancer in May. T. R. Way publishes the first edition of his catalogue of Whistler's lithographs in June. Various events lead to a rupture in Whistler's long friendship and collaboration with the Ways.

1896

Memorial exhibitions held in Boston, London, and Paris. Second, expanded edition of T. R. Way's catalogue raisonné of Whistler's lithographs is published.

1904-1905

1890

Publishes *The Gentle Art of Making Enemies*. Meets Charles Freer of Detroit. Begins work with color lithography, producing an image with the Way firm in London.

1893

Works constantly with transfer paper on lithographic portraits, scenes in the Luxembourg Gardens, and sketches of studio models. Experiments with the "stump" technique. Develops a friendship with Mallarmé, Beardsley, and J. S. Sargent. Young american admirers include Charles Finck, Charles Freer, and Joseph and Elizabeth Pennell, who become his biographers.

1894

T. R. Way proposes a catalogue of Whistler's lithographs. Beatrix becomes ill and the couple returns to London for medical help.

1897

Whistler produces a few more lithographs that are printed in Paris by Lemercier and Clot. He testifies at the libel trial between his old friends, Walter Sickert and Joseph Pennell, which is precipitated by Sickert's attack on the authenticity of lithographs made with transfer paper.

1903

Dies on July 17 in London, Rosalind Birnie Philip, Whistler's executrix, commissions Fredrick Goulding to print posthumous editions of 93 lithographs, 11 of which had remained unprinted during Whistler's lifetime.

"From his earliest use of it, his intuition divined possibilities in this medium that had never been suspected."

Edward Kennedy, eminent cataloguer
Introduction, *The Lithographs of Whistler*, 1914

Early Experiments

In 1878, with the help of Thomas Way, Whistler familiarized himself with lithography and the unusual process of lithotint. He experimented with a variety of crayons as well as ink and brush. With his extraordinary sensitivity to the idiosyncrasies of every medium he employed, Whistler was able—after only a brief apprenticeship—to produce some of his finest lithographs. Working with diluted lithographic inks that he brushed on stone directly, Whistler succeeded in capturing the effects of mist and fog, twilight and darkness that were so beautifully rendered in his paintings. In Whistler's hands, the lithotint process proved an ideal medium for evoking atmosphere and subtle tonalities.

Most of the first efforts were lithotint views of the Thames and its old wooden bridges near the river in Chelsea. His first portraits were images of his model and mistress, Maud Franklin, including a remarkable lithotint, *The Toilet* (no. 10).

Thomas Way also introduced Whistler to transfer paper which he used to make a drawing of Maud and two quick sketches of buildings across from Way's offices on Wellington Street (see no. 7). Although both artist and printer were excited by the early lithographs and convinced they held great promise for the future, the work was almost totally ignored by public and critics alike. Disappointed by this lack of response, in 1879 Whistler departed for Venice and did not return to lithography for eight years.

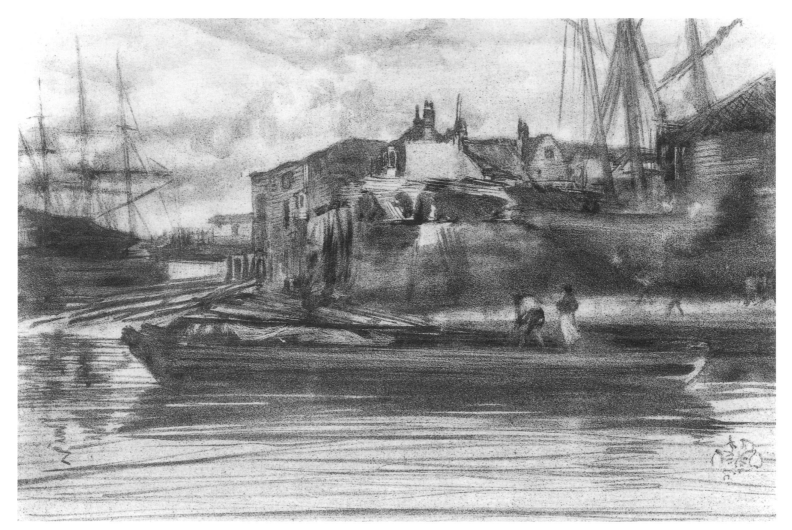

1. *Limehouse* 1878-1887
Lithotint on heavy japan paper
6 3/4 x 10 3/8 inches W. 4; L. 8; C, 7
A proof outside Way's edition

Splashed ink, smudges, and fingerprints beyond the image reveal this impression likely to be a working proof. The use of a larger sheet of absorbent japan paper also differentiates this proof from impressions printed for publication. Whistler undoubtedly worked closely with the Ways when a half dozen copies of the image were pulled in 1878–79 and in 1887 when thirty impressions were pulled for *Art Notes*. The question of dating seems academic for he undoubtedly made many small alterations on the stone. As it began to darken and clog up, re-etching, scraping and varied inkings were tried. As a consequence, it is difficult to find two impressions that are identical and interesting to study the variations in the printings and their tonalities.

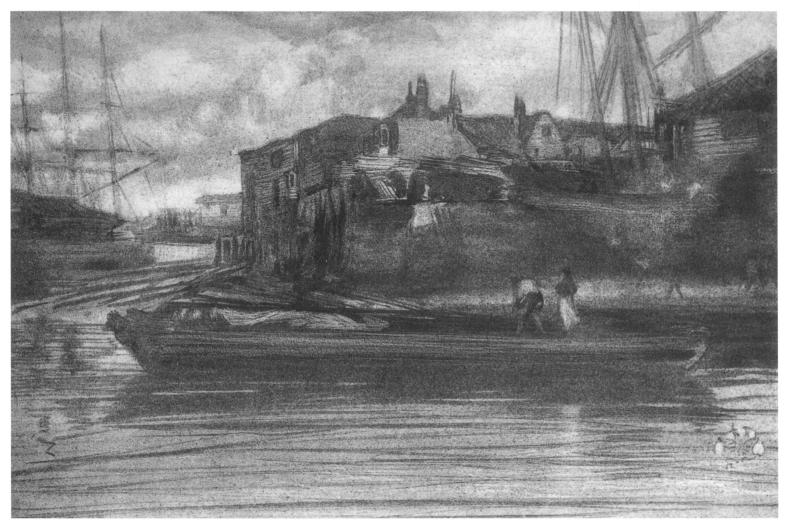

2. *Limehouse* 1878-1887
Lithotint on chine appliqué; signed in pencil
6 3/4 x 10 3/8 inches W. 4; L. 8; C. 7
Way edition: ca.35 proofs; published in *Art Notes* in 1887

The second impression of Limehouse is from the edition printed in *Art Notes*. It is printed on china paper "mounted" on heavy white wove, as indicated for the first thirty proofs issued for the set. The pencil signature is of a style typically used in the late 1880's. As the stone deteriorated and began to clog, the image may have been inked more lightly to prevent the dark areas from printing too black. This may explain why some proofs are found in which the delicate tonalities in the sky are weak and scraped areas ill-defined. This fine impression must have been pulled when the stone was in good condition.

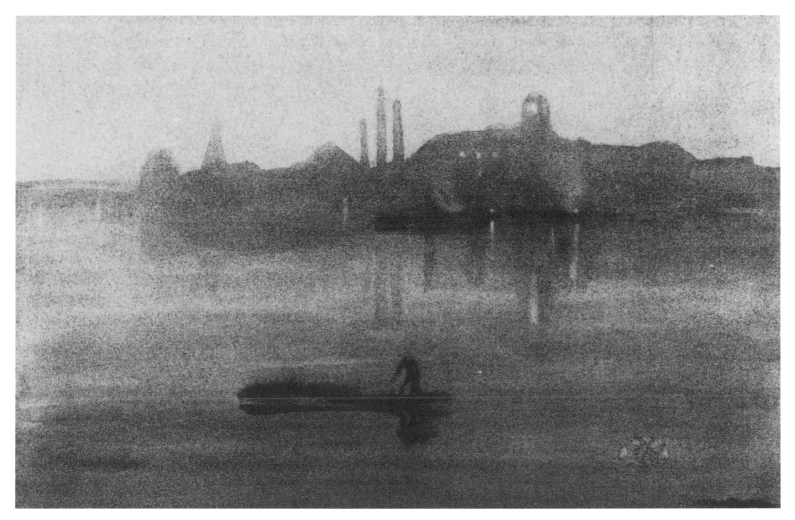

3. **Nocturne** 1878-1887
Lithotint printed on blue-grey paper, laid down on white wove
6 3/4 X 10 1/8 inches W. 5; L. 10; C. 8
Way edition: a few trial proofs and 100 impressions pulled
for *Art Notes* in 1887

The lithotint was executed on a stone prepared by the Ways with an area of half-tint. Whistler then brushed in darker areas with wash and added a few accents in chalk. Highlights, especially in the butterfly, were achieved by scraping away the half-tint on the stone. According to T.R. Way, Whistler worked on the image from memory in the printing office.

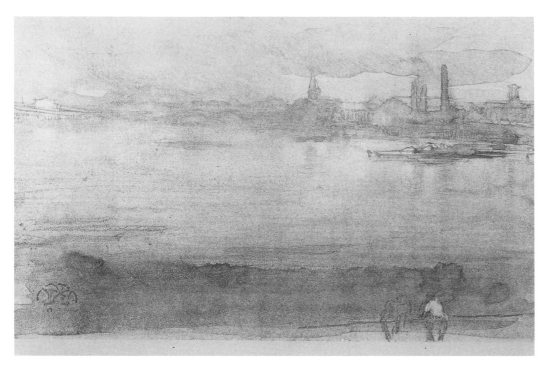

4. *Early Morning* 1878
Lithotint in chalk and wash, on off-white wove paper
6 1/2 x 10 1/4 inches W. 7; L. 16; C. 9
Way edition: about 12 proofs; large edition printed for
Piccadilly but never published

As the machine printing for *Piccadilly* progressed the image
darkened and many impressions were subsequently destroyed.
Originally all impressions except the hand-pulled proofs
carried the names of the magazine and the Way imprint.
T. R. Way said that about fifty of the finest impressions were
saved. He wrote Whistler in 1895 that he had cut the date
and the imprint from the bottom of a group of *Piccadilly*
impressions. (GUL BP 33/49). One of these may be the
example shown here.

5. *The Broad Bridge* 1878
Lithotint in chalk and wash on white wove paper
7 1/4 x 11 inches W. 8; L. 18; C. 11
Collection: unidentified collector's mark
Way edition: 12 proofs; large edition machine printed
by the Ways for *Piccadilly*, published July 1878

Three wooden piers of Old Battersea Bridge appear at low tide.
T. R. Way first alludes to the subject of machine printing when
discussing the lithographs executed for *Piccadilly*. He makes a
distinction between "proofs" and "prints" explaining that "many
hundreds" were printed by the machine, whereas only about
twelve proofs of each stone were pulled by hand. This
impression is printed on the plate paper used for *Piccadilly*.

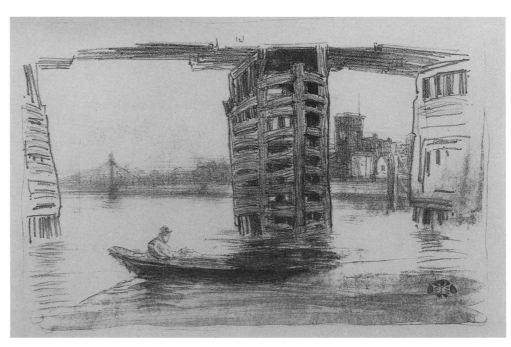

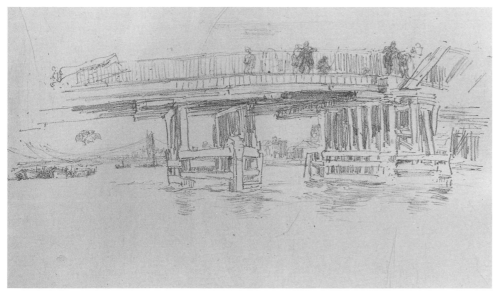

6. **Old Battersea Bridge** 1878
Printed on japan paper laid down on white wove; signed in pencil
5 1/2 x 13 inches W. 12; L. 24 (first state); C. 18
Way edition: a few trial proofs in this state, the second state
was printed in an edition of 100 in 1887 for *Art Notes*
and additional impressions were pulled in the 1890s

The image was drawn directly on stone with the result that
familiar landmarks printed in reverse. Whistler scraped away
some of the suspension cables on the left and replaced this
butterfly with a smaller one. This may be one of six or seven
pulled by Way before the alterations, suggesting it is an early
proof rather than from the edition printed for *Art Notes*.

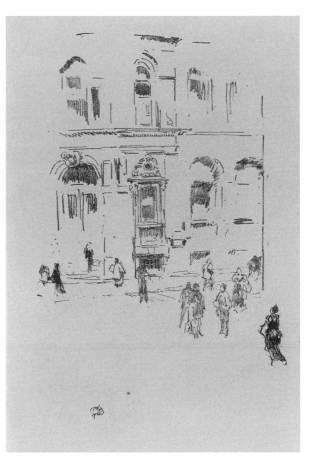

7. **Victoria Club** 1879-1887
Printed on china paper laid down on heavy wove
8 x 5 3/8 inches W. 11; L. 22; C. 15
Way edition: a few trial proofs in 1879 (?); edition of 100
printed for *Art Notes* in 1887

Whistler's original drawing was probably
transferred in 1879. When *Art Notes* was issued as a set eight
years later, he must have added his butterfly to the stone.
It prints in reverse and is of a later style.

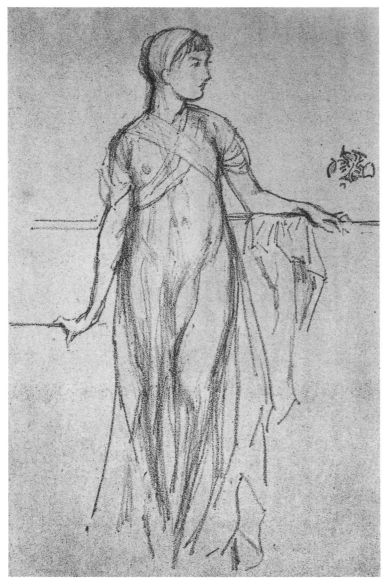

8. *Study* 1879
Printed on grey wove china paper
10 1/4 x 6 1/2 inches W. 15; L. 27; C. 19
Collections: Otto Gerstenberg (L. 1166); Jules Gerbeau (L. 2785)
Way edition: 10 proofs

This image was drawn in chalk on a stone prepared with an area of half-tone; delicate scraping of the ground produced highlights.

9. *Reading* 1879–1887
Printed on old laid paper with foolscap watermark;
signed in pencil
6 x 5 inches W. 13; L. 25; C.17
Collection: Rosalind Birnie Philip (L. 406)
Way edition: 100 proofs for *Art Notes* printed in 1887;
there are undoubtedly a few proofs of earlier states

Although the present study was drawn on the stone in 1879 the butterfly monogram was probably added in 1887. A second state apparently had a larger butterfly signature as well as a few alterations made to the figure for the state shown here.

10. ***The Toilet*** 1878
Printed on wove cream paper, signed in pencil
with the butterfly (when sold after 1888)
10 1/8 x 6 3/8 inches W. 6A; L.12; C.10
First state of two, from the edition of 12

A very fine impression of a rare first state edition, Whistler
held this copy ten years or longer until he sold it for needed
funds. This portrait of Maude Franklin, his second and last
mistress, was drawn together with *Early Morning* on one large
stone. For the second state, he substantially scraped and
lightened the figure; Whistler always worked from dark
to light in the states of his lithotints.

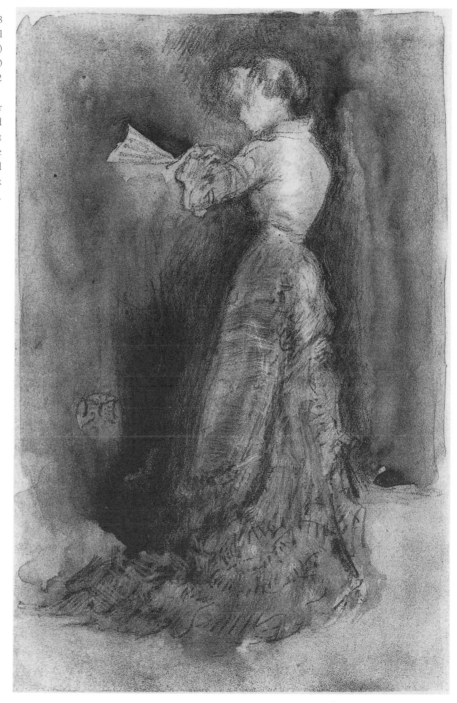

"Seeing beauty where other men might be discouraged by dullness . . ."

Elizabeth R. Pennell
Official biographer of Whistler

Familiar Scenes

When Whistler resumed work in lithography in 1887, he drew most of his images on transfer papers supplied by the Ways. Unencumbered by heavy stones that tied him to the studio, he could move about the city, the countryside, parks, and gardens, carrying nothing more than a few crayons and a packet of the specially prepared paper. He delighted in this freedom, making quick sketches wherever he wandered. His studies of well-known buildings and public places appear as effortless as his vignettes of modest shops, doorways, houses, and courtyards that caught his eye.

He was sometimes disturbed by the conspicuous grain in certain transfer papers and found that he could employ a stump to "brush" warmth and soft tonalities into his images, overcoming difficult textures. This helped him achieve the quiet, "fair" qualities that he sought in his lithographs. Whistler had an uncanny ability to see beauty in the everyday world and to capture its essentials.

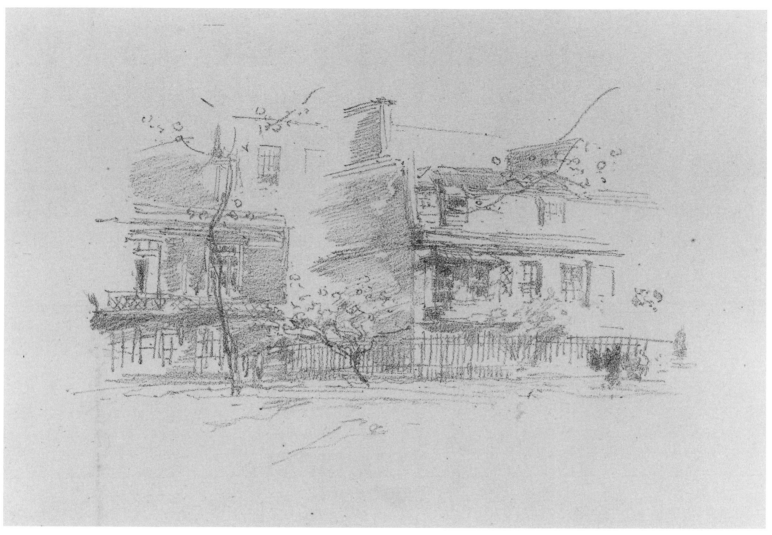

11. *Lindsey Row, Chelsea* 1888
Printed on old laid paper watermarked with crowned coat of arms
with fleur–de–lis and letters WD (?)
5 x 8 inches W. 19; L. 32; C. 23
Collection: Rosalind Birnie Philip (L. 405)
Way edition: 14 proofs; reprinted by Goulding*

Transfer paper was far less cumbersome than limestone slabs, permitting
Whistler to work "on the spot." In this quickly drawn image the mechanical
graining of the early transfer papers which the Ways provided for him is
evident. A similar grainy texture can be seen in *Gaiety Stage Door* (Way 10)
drawn on transfer paper before his sojourn to Venice.

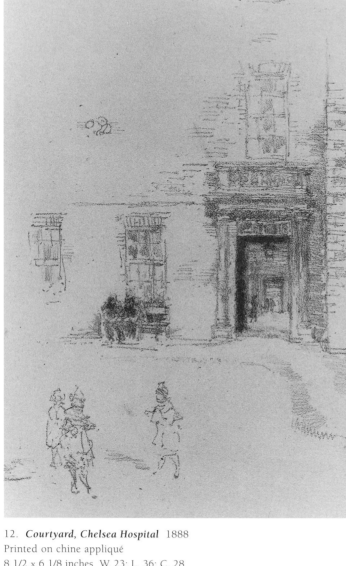

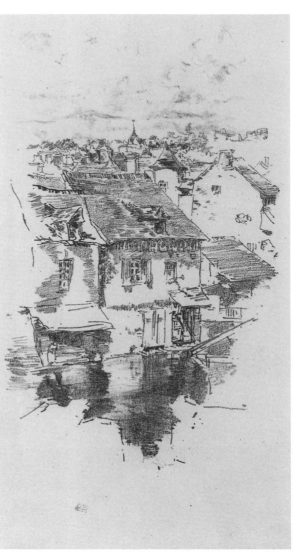

12. *Courtyard, Chelsea Hospital* 1888
Printed on chine appliqué
8 1/2 x 6 1/8 inches W. 23; L. 36; C. 28
Collections: Henry Harper Benedict (L. 2936);
Harris Whittemore (L. Suppl. 1384); Way edition: 6 proofs

This is one of only six known impressions of the image erased by Way on Whistler's instruction. According to Margaret McDonald, it may be the subject listed as *Chelsea Pensioners* in the inventory of lithographs inherited by Whistler's executrix.

13. *Vitré – The Canal* 1893
Printed on fine laid paper, watermarked with rampant lion in crowned circle, signed and numbered (10) in pencil on verso
9 1/4 x 5 7/8 inches W. 39; L. 65; C. 63
Collection: Rosalind Birnie Philip (L. 406)
Way edition: 32 proofs; reprinted by Goulding

Attempting to follow Whistler's careful printing instructions, T. R. Way did experimental drawings of his own to master the problems of transferring the delicate stumping in this view produced in Brittany.

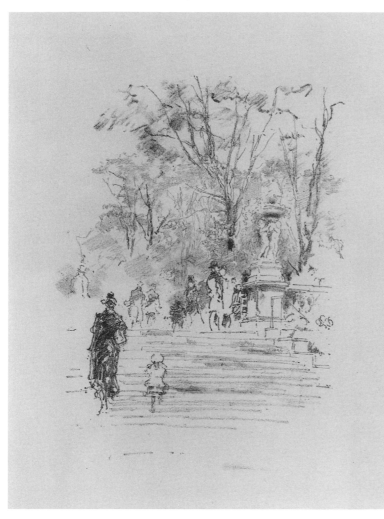

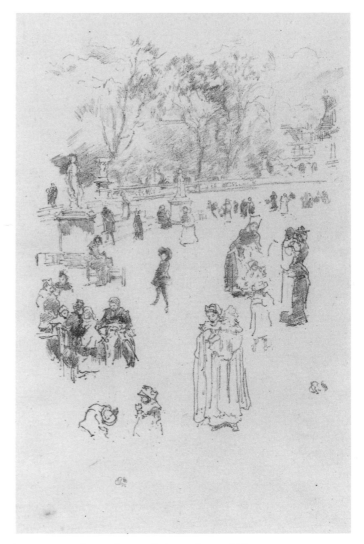

14. **The Steps, Luxembourg** 1893
Lithograph on cream laid paper, watermarked with coat of arms and date
8 1/4 x 6 1/4 inches W. 43; L. 70; C. 68
Way edition: 15 proofs; reprinted by Goulding*

When the Whistlers returned from Brittany the artist drew a series of lithographs in the Luxembourg Gardens near their house. All were drawn on the rather heavily grained German or Austrian transfer paper sent by the Ways from London. But in Brittany Whistler learned which chalks could be best used on this paper to achieve brilliant effects. He employs both hard and soft chalk to obtain rich contrasts and continues to experiment with the stump, which acts to soften the grain of the transfer paper and to suggest texture and atmosphere.

15. **Nursemaids, Les bonnes du Luxembourg** 1894
Printed on antique laid paper, signed in pencil
7 7/8 x 6 1/8 inches W. 48; L. 79; C. 81
Collection: Rosalind Birnie Philip (L. 406)
Way edition: 26 proofs; published in the *Art Journal* in 1896; reprinted by Goulding

Whistler believed this subject suitable for a large printing in the *Art Journal* because he had not used the stump, the delicate quality of which could only be maintained in proofs pulled by hand. This proof pulled from the original stone is highly successful.

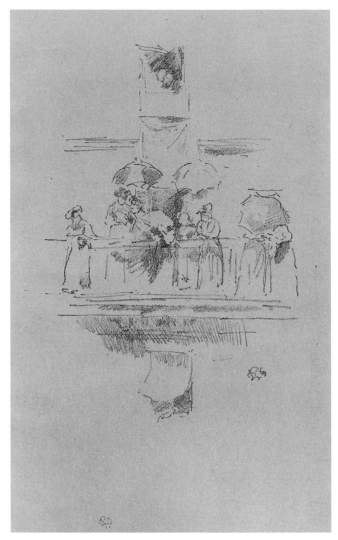

16. *The Little Balcony* 1894
Printed on heavy japan paper, signed in pencil,
also numbered in pencil on verso, possibly in Whistler's hand
7 7/8 x 5 3/8 inches W. 50; L. 81; C. 83
Collection: Rosalind Birnie Philip (L. 406)
Way edition: 28 proofs; reprinted by Goulding

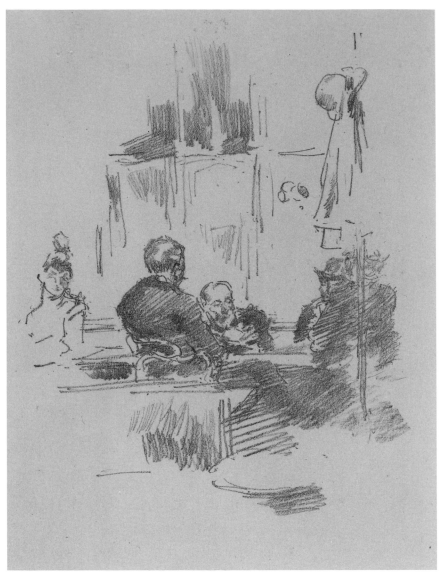

17. *Late Piquet* 1894
Printed on old laid paper with a partial watermark
7 1/8 x 6 inches W. 57; L. 88; C. 94
Collection: Rosalind Birnie Philip (L. 405)
Way edition: 25 proofs; reprinted by Goulding*

A posthumous impression of one of Whistler's Parisian images
—in this instance a group gathered in a cafe playing piquet,
an ancient card game that was popular in Spain, France and Italy.

18. *The Fair* 1895
Printed on antique laid paper
9 1/4 x 6 1/4 inches W. 92; L. 144; C. 135
Collection: Rosalind Birnie Philip (L. 405)
Way edition: 15 proofs; reprinted by Goulding*

Although the drawing may not have transferred with
complete success, the image is convincing,
capturing the artificial illumination of a night scene.

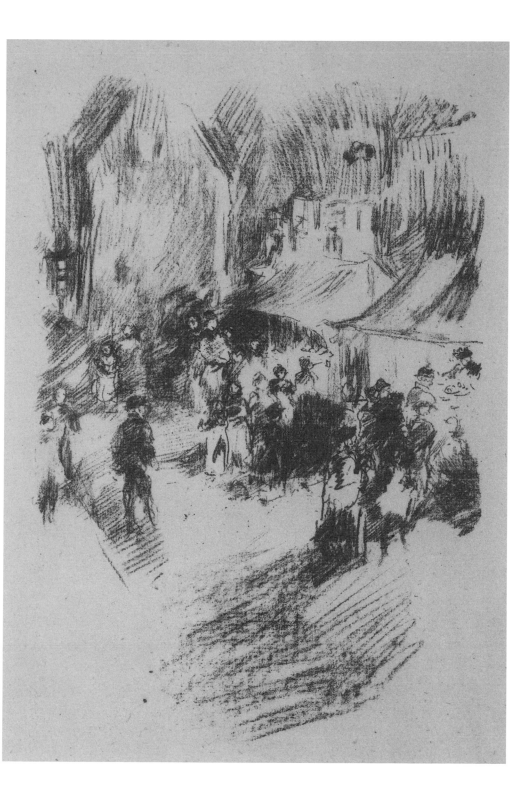

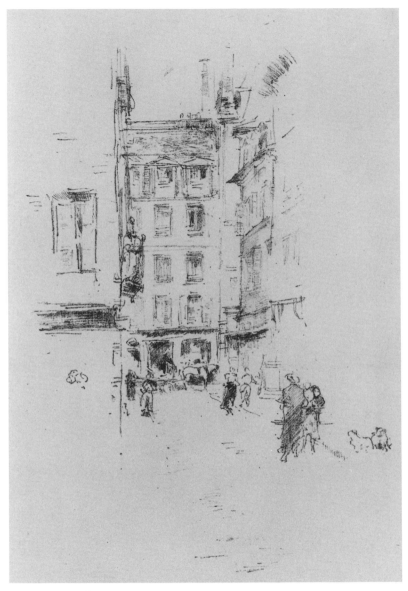

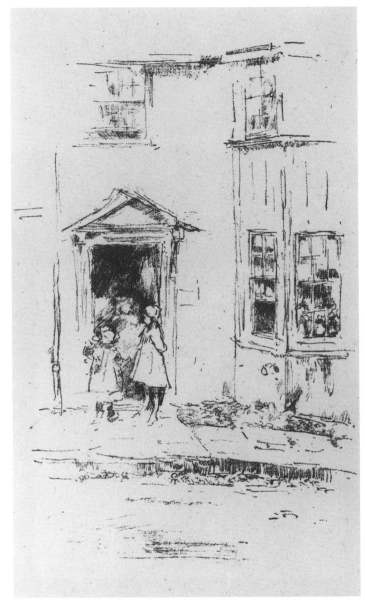

19. *Rue Furstenburg* 1894
Printed on fine old laid paper watermarked crown over letters GR,
signed in pencil
8 1/4 x 6 3/8 inches W. 59; L. 90; C. 97
Collection: Rosalind Birnie Philip (L. 406)
Way edition; 26 proofs; reprinted by Goulding

20. *Little Doorway, Lyme Regis* 1895
Printed on old laid paper with arms of Amsterdam watermark
9 1/8 x 6 1/8 inches W. 83, L. 122; C. 119
Way edition: 15 proofs; reprinted by Goulding*

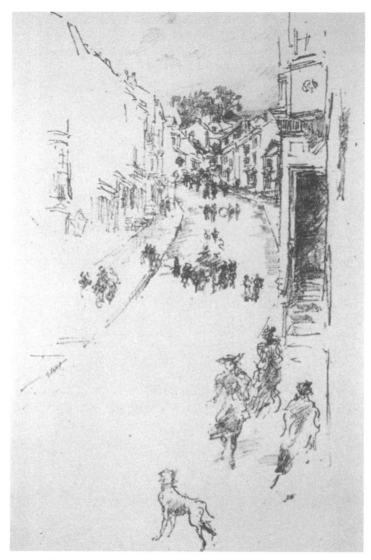

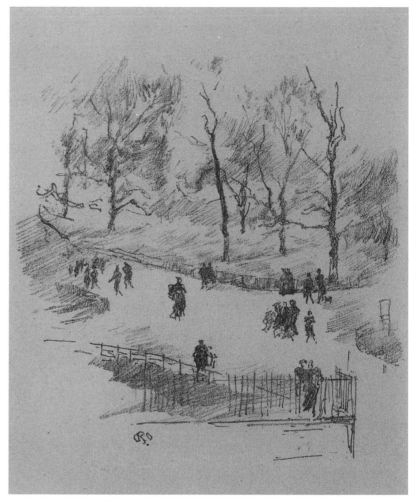

22. **Kensington Gardens** 1895-1896
Printed on fine laid white paper with a partial watermark
6 1/8 x 5 3/4 inches W. 109; L. 158; C. 140
Way edition: 12 proofs; reprinted by Goulding*

21. **Sunday, Lyme Regis** 1895
Printed on antique laid paper (from a ledger?) with a partial watermark, signed in pencil
7 3/4 x 4/1/4 inches W. 96; L. 148; C. 134
Collection: John H. Wrenn (L. 1475)
Way edition: 35 proofs; reprinted by Goulding

The Ways had problems transferring drawings done in Lyme Regis on the smooth, transparent paper that Whistler brought from France. T. R. Way experimented with several other papers until he found one that was superior and acceptable to Whistler.

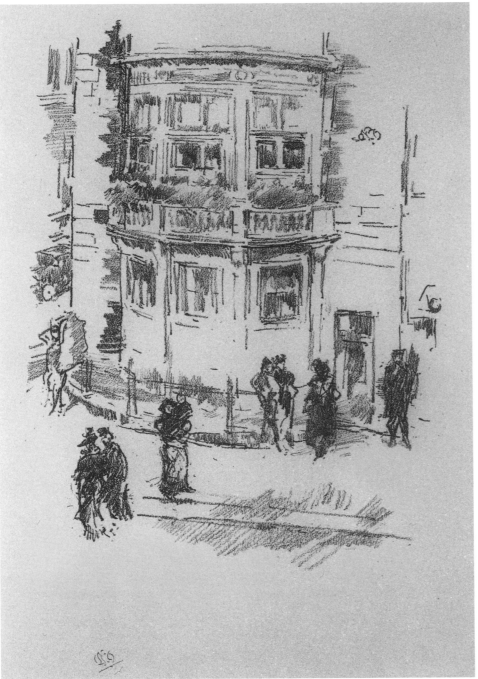

23. **The Manager's Window, Gaiety Theatre** 1896
Printed on off–white wove paper of irregular shape,
signed in pencil
7 x 5 3/8 inches W. 114; L. 162; C. 150
Way edition: 15 proofs; reprinted by Goulding

24. *The Yellow House, Lannion* 1893
Printed in black, three greys, green and ochre on japan paper
9 3/4 x 6 1/2 inches W. 101; L. 196; C. 67
Second state of three from a total of 20 printed by Belfond

This is one of two color lithographs drawn by Whistler while travelling through
Brittany. Throughout the printing of this subject, Whistler continually varied the
number of stones he used (five in this case) as well as the hues of the inks.

25. *The Pantheon, from the Terrace of the Luxembourg Gardens* 1893
Signed in pencil
7 1/8 x 6 3/8 inches W. 45; L. 73; C. 70
This is the only state, one of about 25 impressions
printed by Thomas Way

Whistler used the stumping technique here to suggest the
cloud formations in the sky, the foliage in the middle distance,
and the shadows within the balustrade. There are minor
differences among the impressions.

"To look (at the portraits) and note the charm of expression and vitality exhibited, and the utter absence of any trace of labour or effort, no one would imagine that both artist and subject are said to have almost despaired of making a successful result. It would be interesting to know how many times he commences before the final success."

T. R. Way
Whistler's London Printer

Friends and Associates

Some of Whistler's portraits were done on commission, others undoubtedly to please—and probably flatter—sitters who were friends and colleagues. Even in abbreviated sketches, he was able to capture a likeness with apparent ease. His studies of single figures, often drawn by firelight, have a freshness and vitality that belie the labor and lengthy sittings that may have been involved before he produced an "effortless" likeness.

Generally Whistler eschewed formality in favor of intimacy. Late in his career he hoped to do a series of portraits of children on commission. Because of the uncertainties of his life, only two were completed. (Note his first subject, *Little Evelyn*, no. 34, drawn in 1896.)

26. *La Jolie New Yorkaise* 1894
Printed on laid paper watermarked by Pro Patria, signed in pencil,
also numbered "No. 38" on verso (in Whistler's hand?)
9 x 6 inches W. 61; L. 92; C. 99
Way edition: 25 proofs; reprinted by Goulding

A portrait of Lady Cunard, an American who married into
the Cunard Steamship family, in the 1890s.

27. *The Garden* 1891
Printed on laid paper with
O.W.P. and A.C.L.watermarks
6 3/4 x 7 3/8 inches
(actual size as shown)
W. 38; L.63; C. 40
Way edition: 6 proofs;
reprinted by Goulding*

The group includes
Mrs. Brandon Thomas,
Walter Sickert (standing),
Sidney Starr (a painter who,
like Sickert, was closely
associated with Whistler),
Brandon Thomas (a well-known
playwright), Mrs. Whistler,
and her sister Ethel
(in a "winged" hat).

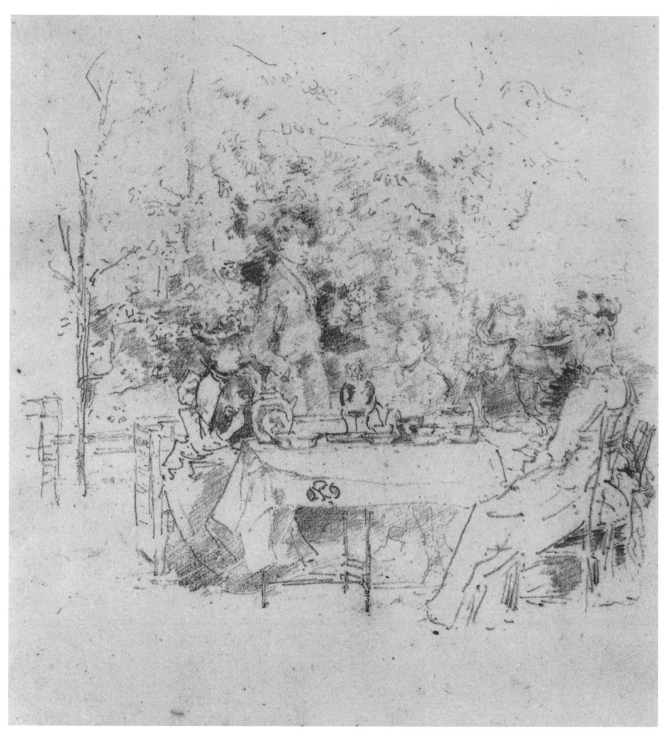

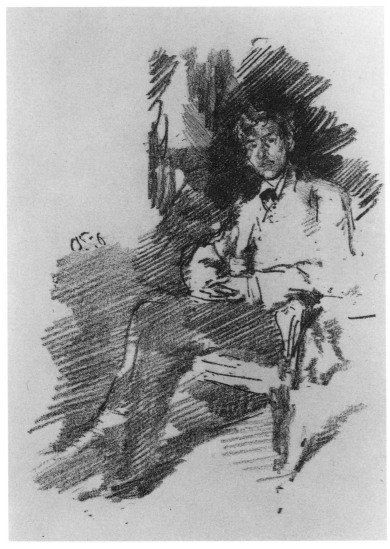

28. *Walter Sickert* 1895
Printed on white wove paper
7 1/4 x 5 1/2 inches W. 79; L. 118; C. 115
Collection: anonymous private collector (not in Lugt)
Way edition: 6 proofs; reprinted by Goulding

Although without a pencil signature, this impression may be a proof
pulled by Thomas Way. Sickert was one of Whistler's early students and
a close friend until their break in 1897.

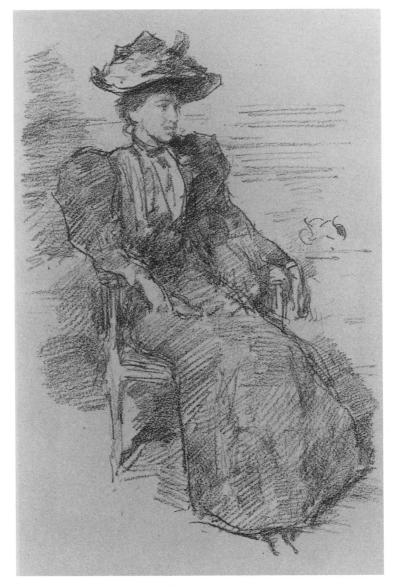

29. *Portrait of Miss Howells* 1894-1895
Printed on chine appliqué, signed in pencil
8 7/8 x 5 7/8 inches W. 75; not in Levy; C. 112
Way edition: number of trial proofs not known;
Way lists 6 proofs but these are undoubtedly of the final state

William Dean Howells was visiting when Whistler drew this portrait of his
daughter, Mildred. The portrait was not transferred until the Whistlers moved
back to London. The artist then reworked the image. This impression appears
to be a trial proof of the earliest state of three.

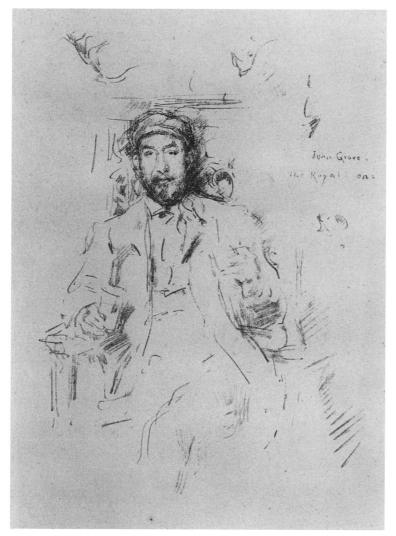

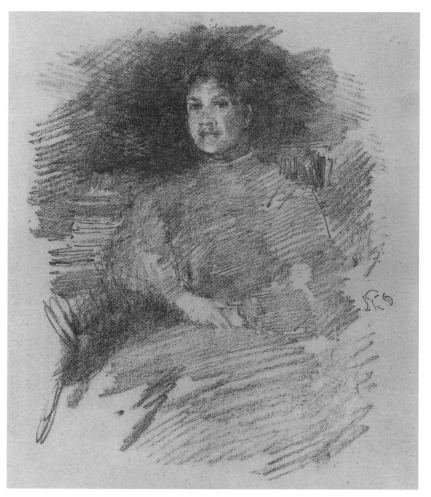

30. *John Grove* 1895
Printed on antique laid paper from a book
8 1/8 x 6 inches W. 93; L. 145; C. 126
Collection: Rosalind Birnie Philip (L. 405)
Way edition: 6 proofs; reprinted by Goulding*

31. *Firelight: Mrs. Pennell* 1896
Printed on cream laid paper torn from an old book
7 3/8 x 6 inches W. 103; L. 151; C. 145
Way edition: 15 proofs; no posthumous printing

A portrait of Elizabeth Robbins Pennell, drawn by firelight.

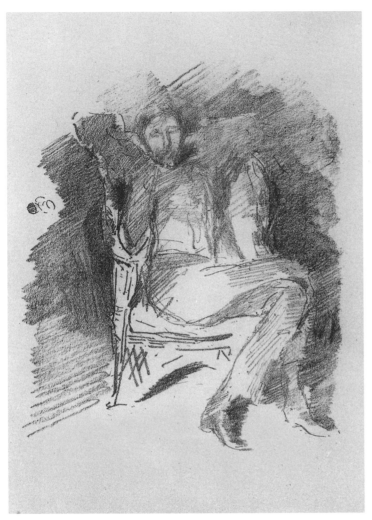

32. *Firelight: Joseph Pennell No. 1* 1896
Printed on cream laid paper with Fortune watermark,
(Van Gelder or Van der Ley manufacture)
6 1/2 x 5 1/2 inches W. 104; L. 152; C. 144
Collection: Rosalind Birnie Philip (L. 406)
Way edition: 15 proofs; published in *Lithography and Lithographers*, 1898

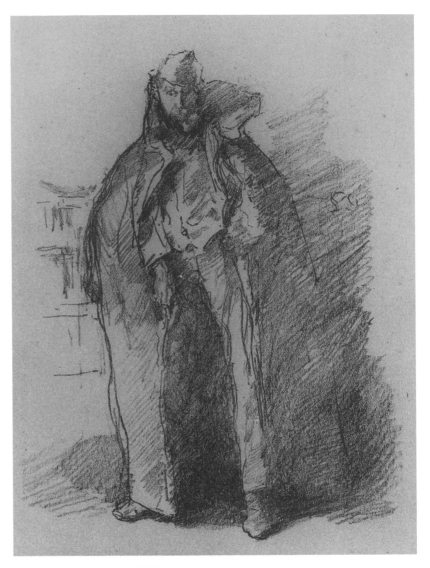

33. *The Russian Schube* 1896
Printed on antique laid paper with an unidentified watermark
7 x 5 7/8 inches W. 112 (undescribed); L. 160 (undescribed); C. 142
Collection: Rosalind Birnie Philip (L. 406)
Way edition: a few trial proofs in this state;
no posthumous printing of the final state

This vivid drawing portrays Whistler's biographer Joseph Pennell. The lighting is
dramatic and it may be that Pennell posed by firelight or gaslight. Interestingly
enough, the impression shown here is a previously undescribed first state before
additional work on the bookcase to the left.

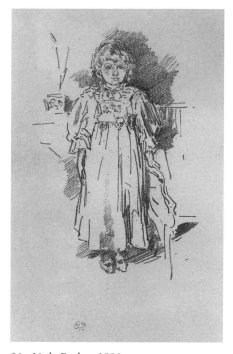

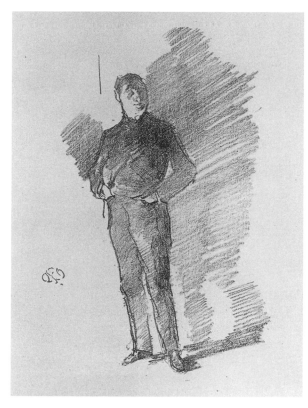

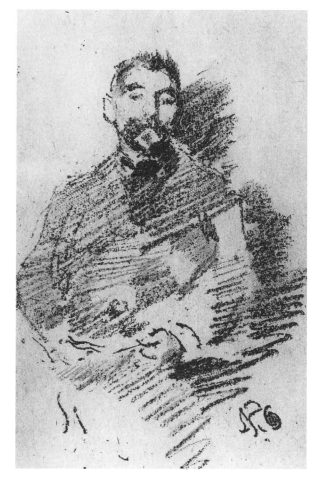

34. *Little Evelyn* 1896
Printed on laid japan paper, signed in pencil
6 1/2 x 4 1/2 inches W. 110; L. 159; C. 146
Collection: Rosalind Birnie Philip (L. 406)
Way edition: 15 proofs; published in the *Art Journal,* in 1896;
reprinted by Goulding

This is a portrait of the daughter of art dealer
D. Croal Thomson and the first subject in a
proposed series on children that never mate-
rialized.

35. *Study No. 2* 1896
Printed on cream laid paper,
watermarked Van Gelder Zonen
7 3/8 x 4 3/4 inches W. 108; L. 156; C. 152
Way edition: 6 proofs; reprinted by Goulding*

The second of two portraits of the elder Thomas Way,
drawn in the Way's office on Wellington Street only months
before their long friendship came to an end.

36. *Stéphane Mallarmé* 1892
Drawn on transfer paper in 1892
Printed on chine appliqué 1893–94
3 x 4 3/4 inches W. 66; L. 101; C. 60
Used as the frontispiece for the first editions of Mallarmé's
Vers et Prose in 1893 and printed by Belfond studios
in Paris as a lithograph in 1894

This is a rich impression, representing Whistler's first
experiment with textureless French transfer paper.

". . . drawn with the fewest lines of the grayest color—yet so clearly and firmly put down . . . so full of suggested movement . . . the drapery helps to express rather than hide the modeling of the flesh beneath, it sways and floats with the movement of the body . . ."

<div align="right">T. R. Way</div>

Studio Models

Whistler not only delighted in capturing vignettes on transfer paper as he wandered through the streets and gardens of London and Paris, he also found transfer paper an ideal material for drawing young models who posed sitting or moving about in his studio. Occasionally posing nude, they were more frequently clad in diaphanous classical gowns or Japanese robes that he provided for the modeling sessions. A few of them became special favorites and repeatedly appear dancing, dressing, resting, or posing with a baby or young child. At times these models posed for etchings, but most appear in a long succession of delicate pastels, watercolors, and light filled lithographs. Whistler preferred the fluidity of crayon, colored chalk, and watercolor when he set out to reflect the lightness and grace of his youthful subjects.

All save two of his seven color lithographs were posed by studio models in London or Paris. Perhaps the original inspiration for the studies of lightly draped models grew from Whistler's interests in Greek culture and in the recently excavated Tanagra figurines being collected in London, but he worked so persistently drawing the slender models that it is clear he enjoyed the challenge of capturing their transitory movements and ephemeral beauty.

37. *The Dancing Girl* 1890
Printed on old laid paper,
watermarked IVDL (Van der Lay), signed in pencil
7 1/8 x 5 3/4 inches (actual size as shown) W. 30; L. 45; C. 29
Collection: Rosalind Birnie Philip (L. 406)
Way edition: 32 proofs; reprinted by Goulding

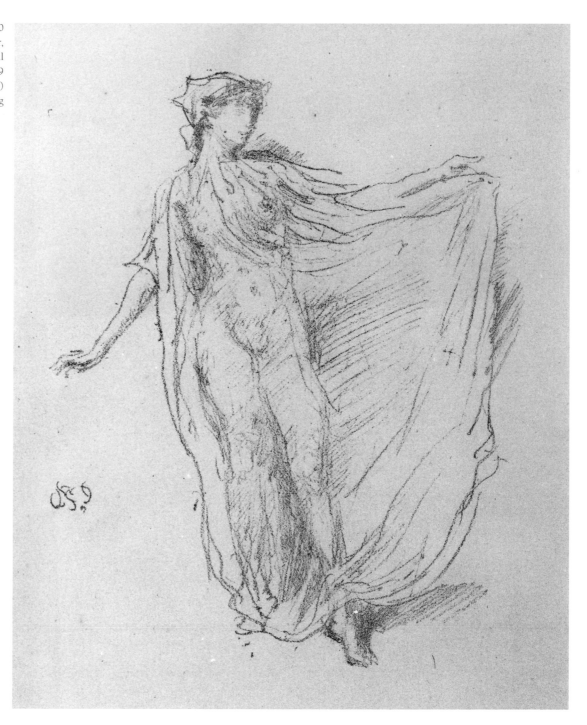

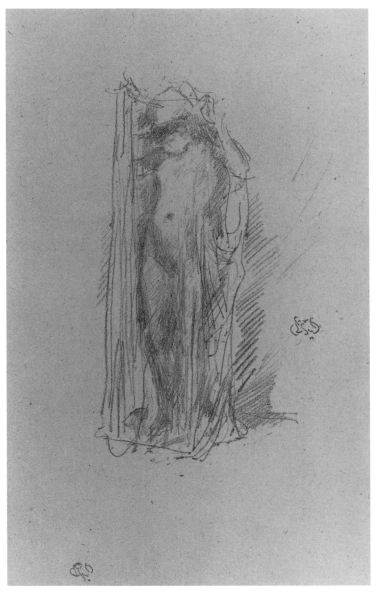

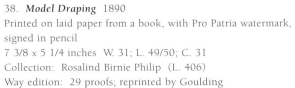

38. *Model Draping* 1890
Printed on laid paper from a book, with Pro Patria watermark,
signed in pencil
7 3/8 x 5 1/4 inches W. 31; L. 49/50; C. 31
Collection: Rosalind Birnie Philip (L. 406)
Way edition: 29 proofs; reprinted by Goulding

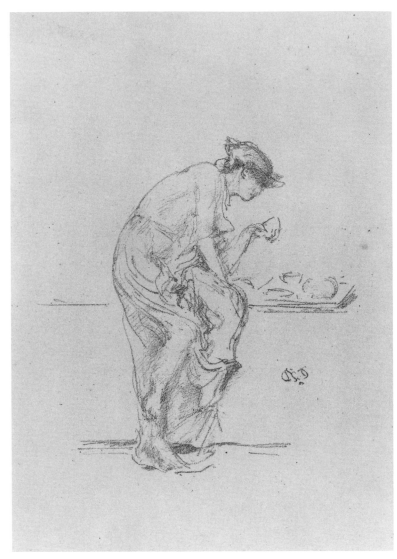

39. *The Horoscope* 1890
Printed on laid paper, watermarked
6 3/8 x 6 1/4 inches W. 32; L. 51; C. 30
Way edition: 6 proofs; reprinted by Goulding*

Although Rosalind Birnie Philip's round stamp is not on this sheet, it is
assumed to be a posthumous impression.

40. *Little Nude Model, Reading* 1890
Printed on fine old laid paper,
signed in pencil
6 5/8 x 7 inches W. 29; L. 44; C. 33
Collection: Rosalind Birnie Philip
Way edition: 28 proofs;
reprinted by Goulding

This is one of a group of lithographs of
young models done in 1890 on
mechanically grained transfer paper of
Scottish or German manufacture.
Unlike the others, Whistler seems to
have been pleased with this drawing
from the first and had no thought of
erasing it from the stone.

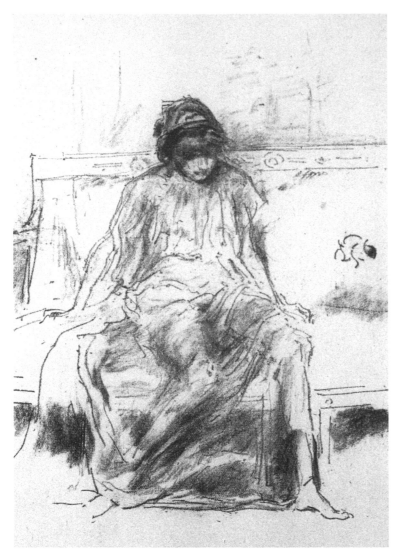

41. *The Draped Figure–Seated* 1893
Printed on fine antique laid paper
7 1/8 x 6 3/8 inches W. 46; L. 74; C. 72
Way edition: 15 proofs; printed by the Ways from the original stone in
an edition of about 107 for *L'Estampe Originale*; reprinted by Goulding*

This splendid impression was probably printed posthumously and
amply demonstrates both the care the Ways took of the original stone
and the quality of the printing done in Goulding's shop when the
reprinting was carried out in 1904. Whistler has used the stump
throughout to create both delicate and deep shadows.

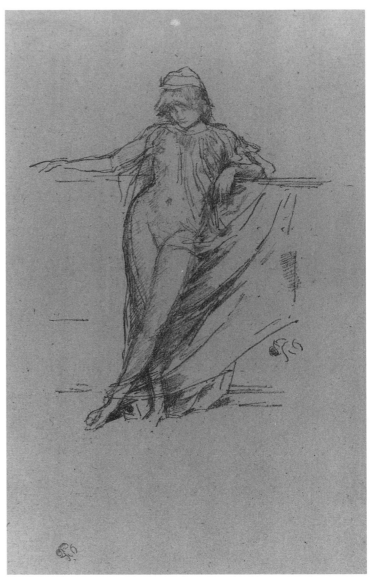

42. *Little Draped Figure–Leaning* 1894
Printed on old laid paper with Pro Patria watermark, signed in pencil
7 x 5 3/4 inches W. 51; L. 82; C. 76
Collection: Rosalind Birnie Philip (L. 406)
Way edition: 48 proofs; reprinted by Goulding

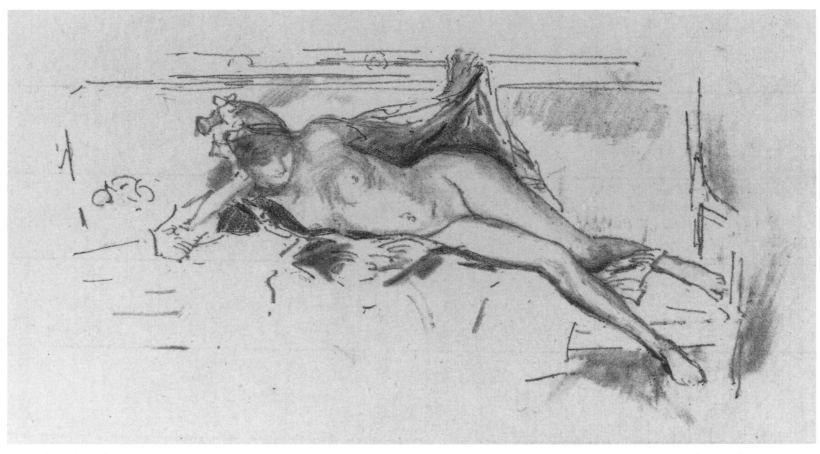

43. **Nude Model Reclining** 1893
Printed on very fine antique laid paper
4 1/2 x 8 3/8 inches W. 47; L. 75; C. 73
Collection: Rosalind Birnie Philip (L. 405)
Way edition: 25 proofs; reprinted by Goulding*

This impression, pulled in Goulding's shop, indicates the care taken in selecting old papers and in inking the stones for the finest of the posthumous printings.

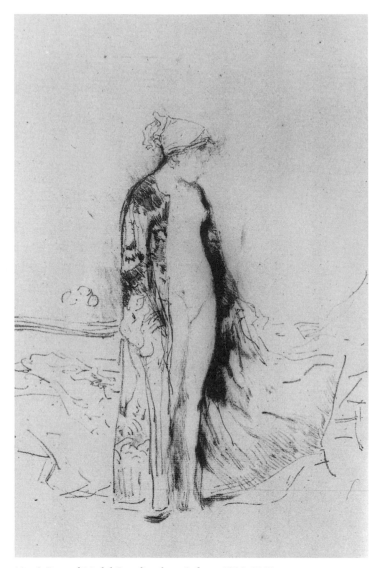

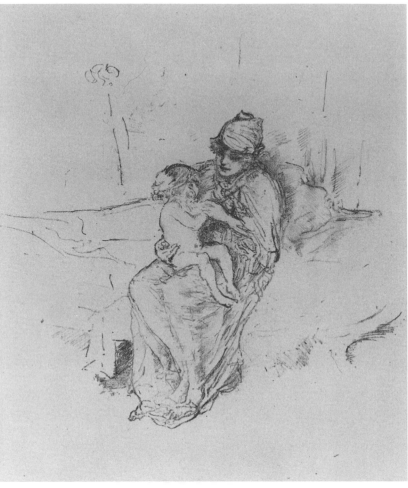

45. *Mother and Child, No. 1* c. 1890–1895
Printed on off–white laid paper with Van Gelder Zonen watermark
7 1/8 x 7 1/2 inches W. 80; L. 119; C. 51
Collection: Rosalind Birnie Philip (L. 406)
Way edition: 33 proofs; reprinted by Goulding

According to T. R. Way Whistler reworked a number of his lithographic stones in 1895 when he returned to London. If the original drawing was done in 1890 as Way suggests, he may have added the work with the stump when the drawing was transferred in 1895.

44. *A Draped Model Standing by a Sofa* c. 1890–1895
Printed on fine laid paper, watermarked D. & C. Blauw and crowned shield with posthorn
8 1/2 x 8 1/2 inches Not in Way; L. 187; C. 75
Edition: printed by Goulding in 1904

Among the "untried drawings" she inherited, Rosalind Birnie Philip lists a *Nude in Japanese Robe* that must be this image. The posthumous edition was small and the print is rare.

46. *Draped Figure Reclining* 1890–1893
Printed by Belfond on thin laid japan paper in
gray, green, pink, yellow, blue, and purple,
signed in pencil and dedicated "à Monsieur Belfond"
7 x 10 3/8 inches W. 156; L. 194; C. 56
Collections: Belfond; Jules Chavasse (L. 1430), sold 1919;
Knoedler, N.Y.; Marshall Field; Mrs. Diego Saurez
Edition: small number of trial proofs, printed by Belfond in Paris

Whistler's excessively rare color lithographs deserve special study.
His first color print, *Figure Study No. 1*, was done in 1890 and
printed by the Ways. There were problems with the printing and
Whistler apparently decided to work with the Belfond studio in
Paris. The image shown here, sometimes referred to as *Study in
Color No. 2*, uses the same model in a different pose and was proba-
bly drawn in London about that same time and later taken to Paris
for transfer. The colors in each proof of each color impression vary;
each is, in effect, a trial proof pulled as Whistler worked beside
Belfond mixing inks. The dedication to the printer on this particular
proof suggests that both the artist and lithographer approved these
muted harmonies. Sometime later Belfond had financial difficulties;
the firm closed in 1894 and Whistler was angered to learn that
Belfond sold this extraordinary impression. Subsequently, Whistler's
highly individual exploration of color ceased.

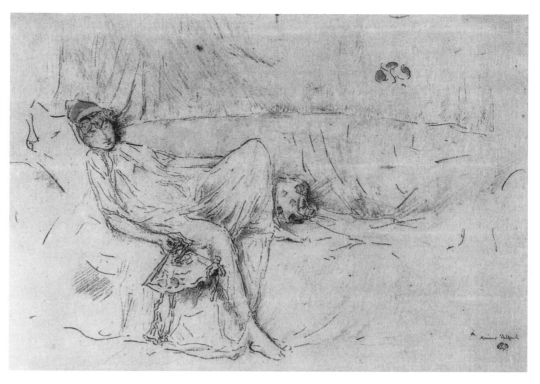

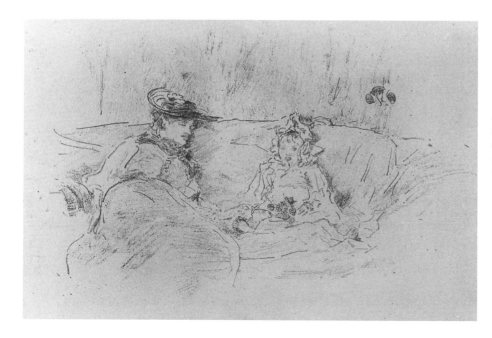

47. *Lady and Child* 1890–1893
Printed by Belfond on heavy white wove paper in yellow,
red, blue, brown, green, and black
5 7/8 x 8 7/8 inches W. 157; L. 176; C. 55
Collection: Rosalind Birnie Philip (L. 406)

Although T. R. Way describes this as printed in three colors, six
stones were required for the impression shown here. Whistler's
executrix, Rosalind Birnie Philip, inherited eight proofs of the
image, but this impression must have been one of the finest.
Registration is perfect and the colors clear and beautifully balanced.

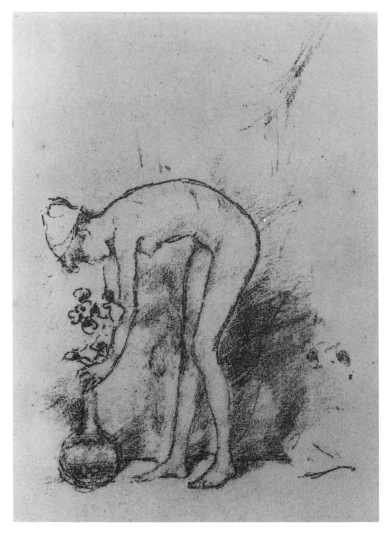

48. *Nude Model Arranging Flowers* 1890–1896
Printed on laid japan paper with partial watermark with crown
6 3/4 x 4 1/2 inches Not in Way; L. 172; C. 57
Edition: printed by Goulding in 1903

It is difficult to date this drawing, which may be a late copy of an earlier
pastel. Alternatively, it could have been done as early as 1890. It is listed in
Rosalind Birnie Philip's ledger as "untried transfer *no. 6–Little Nude Model
with Flowers in Pot.*"

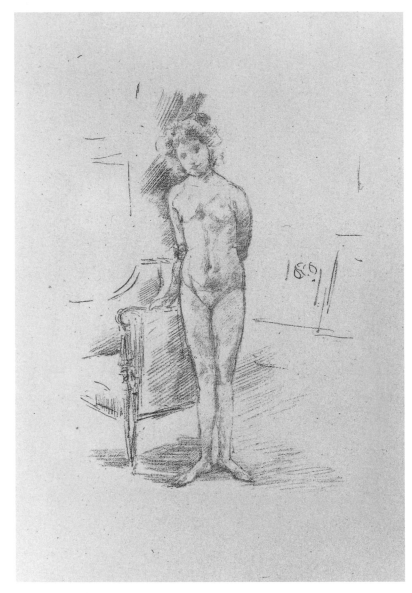

49. *Little London Model* 1890–1896
Printed on old laid paper with Anne of Amsterdam watermark
6 3/4 x 5 inches W. 130; L. 184; C. 168
Way edition: 8 proofs; reprinted by Goulding*

According to T. R. Way, this was the last lithograph he and his father printed in their
office on Wellington Street.

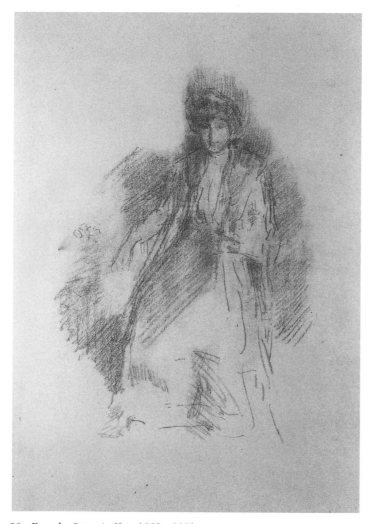

50. *Dorothy Seton in Hat* 1902 - 1903
Printed on laid paper with O.W. P. & A.C. L. watermark
7 1/4 x 5 5/8 inches Not in Way; I 191; C. 172
Posthumously printed by Goulding, November 1903

This is recorded in Rosalind Birnie Philip's ledger as an "untried transfer," probably a drawing on paper that had not been put on stone. Although the chalk may have become smudged before Goulding transferred the image, the soft shading may be the result of stumping.

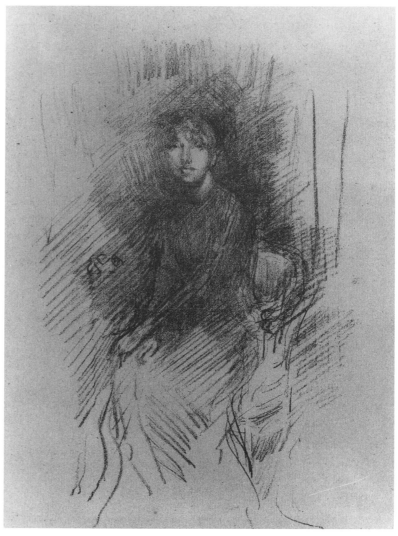

51. *Dorothy Seton* 1902- 1903
Printed on fine old laid paper
7 3/4 x 5 1/4 inches Not in Way; L. 192; C. 171
Posthumously printed by Goulding, November 1903

". . . figures full of character and suggested action, lit by the flickering forges and rays of sunlight, in interiors full of all sorts of tools and materials such as one always finds in such places, yet always drawn with such selection that they make perfect compositions and express just what he intended us to see."

T. R. Way

Smithies, Shops, and Tradesmen

Throughout his career as a printmaker, Whistler was attracted by views glimpsed through doorways into recessed interiors and by simple facades of picturesque shops and houses. A number of his lithographs, such as *The Tyresmith* (no. 54, 1890), *The Whitesmiths, Impasse des Carmelites* (no. 57, 1894), and *The Smith's Yard* (no. 61, 1895), address these interests. Others, such as the studies made at the Govier's smithy in Lyme Regis, show quickly drawn figures that can readily be identified by comparison with contemporary photographs. Frequently, his lithographs focus on facades and their patterns of doorways and windows. Viewed frontally and thereby rendered two-dimensional, it was the play of abstract patterns that caught Whistler's eye.

The arrangement of doors and windows in sunlight and shadow within the rectangle of paper appealed to his interest in formal relationship. With few exceptions, the strict geometry of these compositions is relieved by a curved awning, shopkeepers glimpsed faintly through the windows, and the figures of small children, animals, and passersby that give images a vitality and immediacy which enliven his abstract vision.

52. *Chelsea Rags* 1888
Printed on cream laid paper
with O.W.P. & A.C.L. watermark
7 1/8 x 6 1/4 inches (actual size as shown)
W. 22; L. 35; C. 26
Collection: Rosalind Birnie Philip (L. 405)
Way edition. 13 proofs; published in *Albemarle*,
January 1892; reprinted by Goulding*

Large printings for periodicals such as *Albemarle*
were done by machine in the Way shop from a
number of additional stones prepared for large
printings. It may be assumed that Goulding's
reprints were made from the carefully preserved
stone bearing Whistler's original transfer.

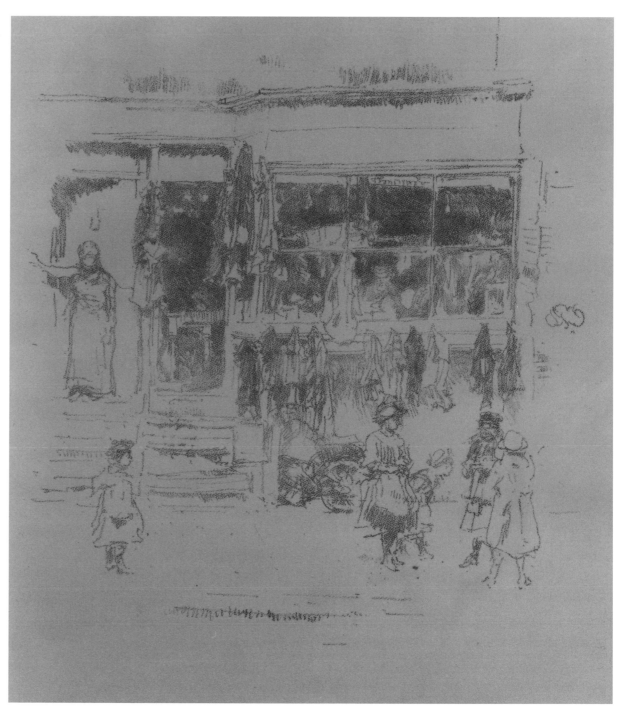

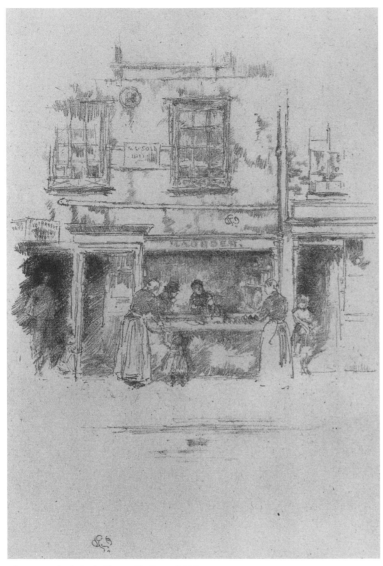

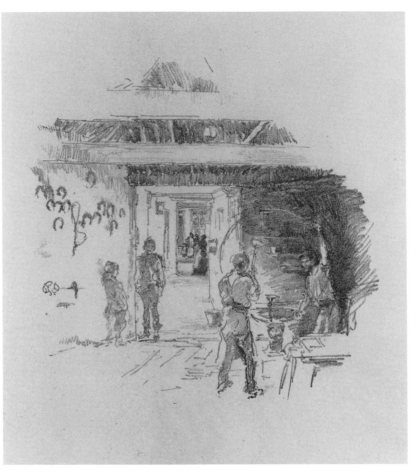

54. *The Tyresmith* 1890
Printed on cream laid paper with O.W.P. and A.C.L. watermark
6 1/2 x 7 inches W. 27; L. 41; C. 38
Way edition: 8 proofs; published in the *Whirlwind*, November 1890;
reprinted by Goulding*

Although lacking R. B. Philip's posthumous stamp, this is undoubtedly one
of the editions printed in 1904 under her supervision.

53. *Maunder's Fish Shop, Chelsea* 1890
Printed on old laid paper with unidentified watermark, signed in pencil
7 1/2 x 6 3/4 inches W. 28; L. 42; C. 37
Collection: Rosalind Birnie Philip (L. 406)
Way edition: 28 proofs; published in the *Whirlwind,* December 20, 1890;
reprinted by Goulding

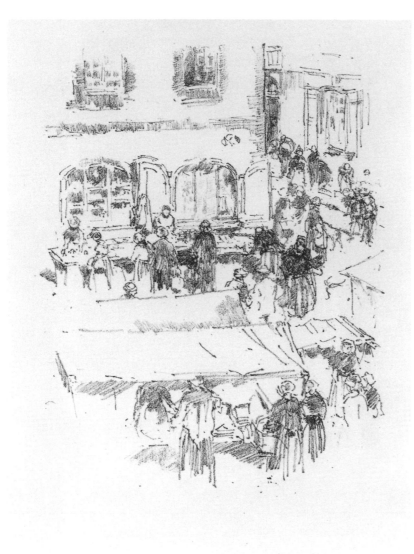

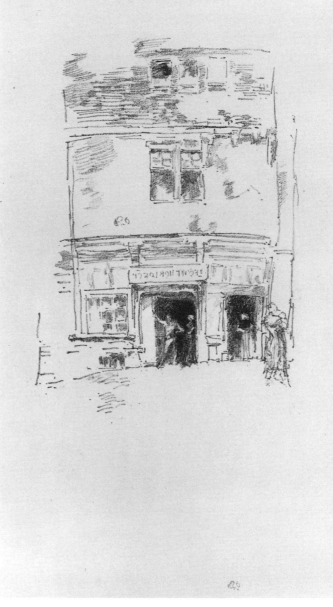

55. *The Market-Place, Vitré* 1893
Printed on antique laid paper from a book
7 7/8 x 6 1/4 inches W. 40; L. 66; C. 62
Way edition: 12 proofs; reprinted by Goulding*

According to lists compiled by Whistler and Rosalind Birnie Philip
the correct locale was Paimpol, not Vitré.

56. *The Clock–Makers Paimpol* 1893
Printed on fine laid paper, signed in pencil
8 x 5 3/4 inches W. 42; L. 68; C. 65
Collection: Rosalind Birnie Philip (L. 406)
Way edition: 12 proofs; reprinted by Goulding

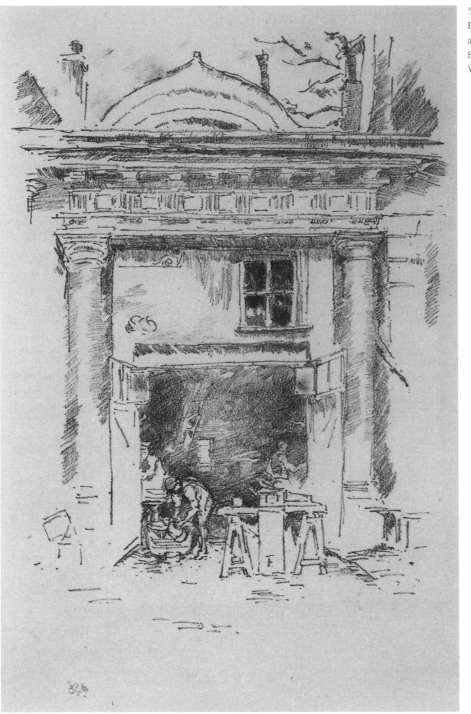

57. *The Whitesmiths, Impasse des Carmelites* 1894
Printed on heavy laid japan paper, signed in pencil
and numbered "4" in pencil on recto
8 5/8 x 6 3/8 inches W. 53; L. 84; C. 92
Way edition: 28 proofs; reprinted by Goulding

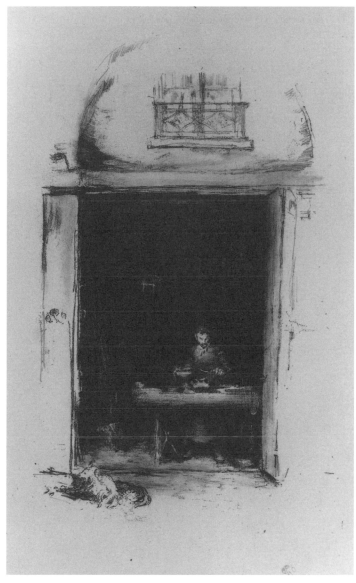

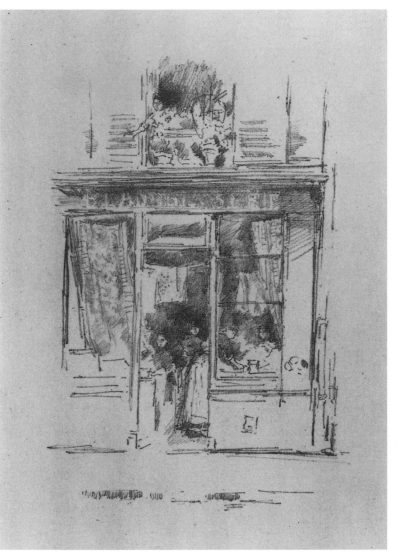

58. *The Smith, Passage du Dragon* 1894
Printed on cream laid paper with O.W.P. & A.C.L. watermark
10 3/8 x 6 7/8 inches W. 73; L. 109; C. 103
Collection: Rosalind Birnie Philip (L. 405)
Way edition: 34 proofs; reprinted by Goulding*

In this instance Whistler drew on the smooth, transparent *papier vegetal*
obtained from Lemercier. Whistler later retouched the stones in London
(probably 1895).

59. *The Laundress, La blanchisseuse de la Place Dauphine* 1894
Printed on laid paper with watermark of crowned shield
with posthorn above D. & C. Blauw
9 x 6 1/8 inches W. 58; L. 89; C. 93
Way edition: 25 proofs; reprinted by Goulding*

When Whistler sent the drawing to London for transfer on August 7, 1894,
he described it to T. R. Way as "perhaps the best drawing I have done. It has no
stump and ought to come out perfectly" (letter in Freer Gallery of Art Archives).

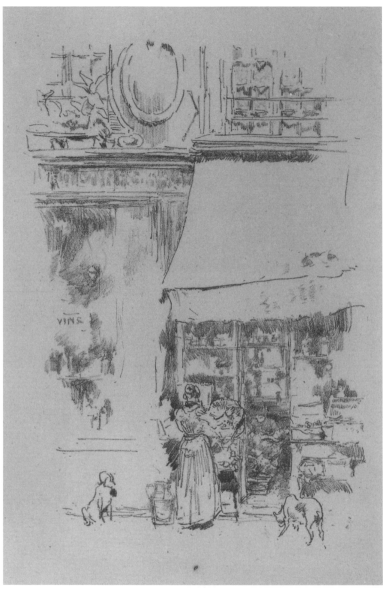

60. *La fruitière de la rue de Grenelle* 1894
Printed on old laid paper from a ledger with letters watermark 4N,
signed in pencil
9 x 6 1/8 inches W. 70; L. 98; C. 106
Collection: Rosalind Birnie Philip (L. 406)
Way edition: 33 proofs; reprinted by Goulding

61. *The Smith's Yard* 1895
Printed on cream laid paper with watermark, crown above GR,
signed in pencil
7 1/4 x 6 1/4 inches W. 88; L. 126; C. 124
Collection: Rosalind Birnie Philip (L. 406)
Way edition: 35 proofs; published in the *Studio;* reprinted by Goulding

A large edition was printed from additional stones for the *Studio,* but this
impression was pulled from the original stone by the Ways.

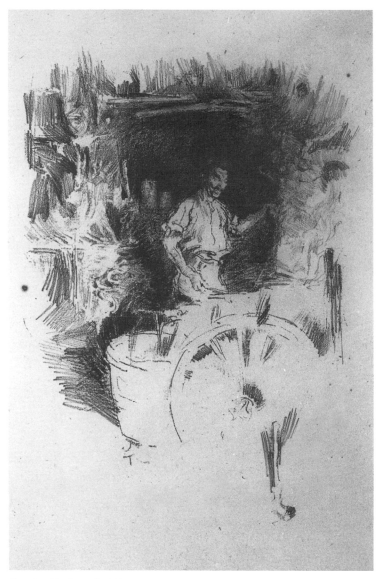

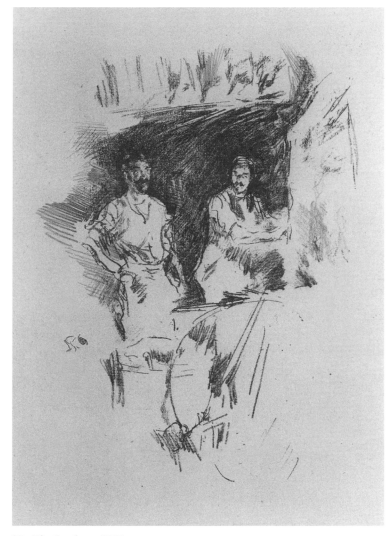

62. *The Blacksmith* 1895
Printed on old laid paper with unidentified watermark
8 1/4 x 6 inches W. 90; L. 128; C. 127
Collection: Rosalind Birnie Philip
Way edition: 15 proofs; reprinted by Goulding*

According to T. R. Way, there were two earlier states, undoubtedly produced when
Whistler reworked the stone to strengthen the original transfer.

63. *The Brothers* 1895
Printed on cream laid paper with Van Gelder Zonen watermark
8 x 5 1/2 inches W. 91; L. 131; C. 128
Way edition: 15 proofs; reprinted by Goulding*

This impression indicates the brilliance of the finest posthumous printings.

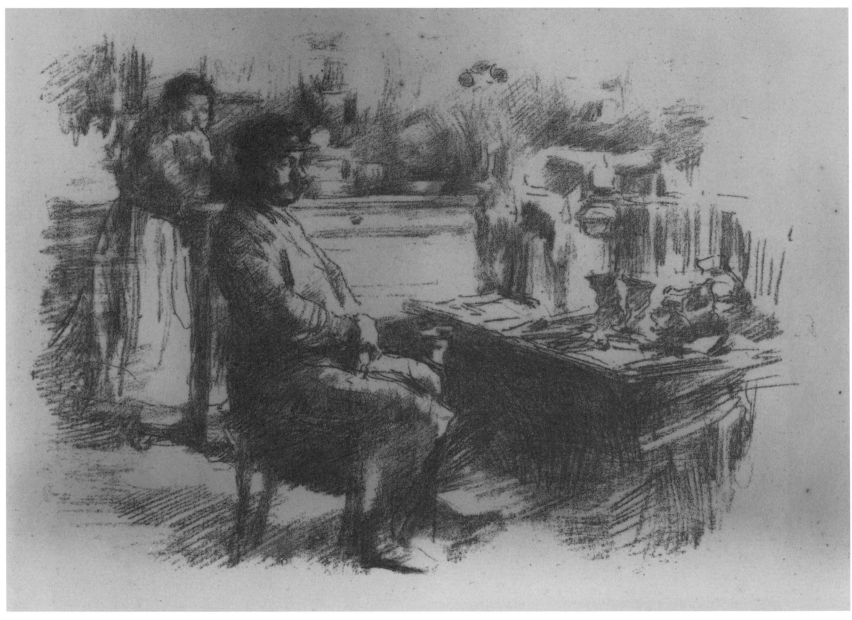

64. *The Shoemaker* 1893–1895
Printed on old laid paper from a book watermarked baslerstab in cartouche of shields (?)
6 1/4 X 8 3/4 inches (actual size shown) W. 151; L. 129; C. 169
Collection: Rosalind Birnie Philip (L. 405)
Edition: number unrecorded; reprinted by Goulding*

Drawn in Dieppe, this image was printed in Paris, and the stone "left in Lemercier's hands," according to Birnie Philip. The stone was retrieved and she authorized a posthumous edition.

65. **The Old Smith's Story** 1895
Signed in pencil
7 1/2 x 6 1/4 inches W. 145; L. 150; C. 130
The only state of about 15 impressions
printed by Thomas Way

During the Whistlers' stay at Lyme Regis,
Dorset, in the autumn of 1895, after
Beatrix's illness forced them to leave Paris,
Whistler made studies in the Govier
blacksmith shop on Broad Street. The image
features the distinctive figure of the elderly
Govier; his oldest son works the bellows.

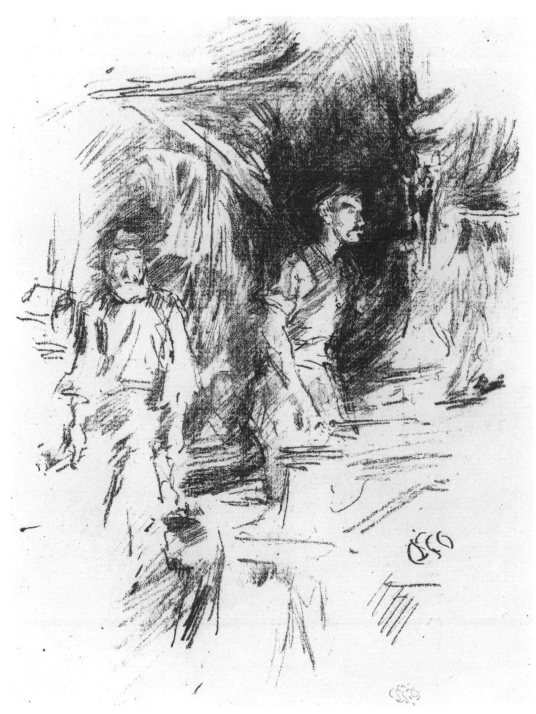

"To look (at the portraits) and note the charm of expression and vitality exhibited, and the utter absence of any trace of labour or effort . . ."

T. R. Way

Family Portraits

Whistler made only three lithographs of his own siblings—two of his brother and one of his half-sister, Deborah, the wife of Seymour Haden (see *Unfinished Sketch of Lady Haden*, no. 78, 1895). The transfer drawings of his brother were executed when Dr. Whistler traveled to Paris from London to assess Beatrix's failing health (see *The Doctor,* no. 79, 1895). Like most of Whistler's portraits of family members, the images of the doctor are brief sketches drawn as he enjoyed a glass of wine. Typically, peripheral detail is eliminated and our eyes focus on the sitter.

After Whistler's marriage, Beatrix's sisters and their mother visited the couple frequently in Paris and London. Ethel and Rosalind Birnie Philip posed often in the sitting room and in the garden at 110 rue du Bac. While two early portraits of Ethel drawn in London, *The Winged Hat* and *Gants de suede* (nos. 66 and 67) are striking and quite formal, later images—largely drawn in Paris—show family members relaxing, sewing, having tea, making music, engaged in conversation, or enjoying the garden behind the house.

Several of his images of Trixie resting, after the onset of her illness, are particularly tender and intimate. When viewed as a group, the portraits reveal the happiness Whistler found in the company of his wife's family and the pleasure he took in capturing their private moments with his lithographic crayons. After his wife's death, Whistler's few lithographs were almost exclusively portraits of Mrs. Philip, Ethel, and Rosalind.

66. **The Winged Hat** 1890
Printed on laid paper with O.W. P. and
A.C.L. watermark
7 X 6 3/4 inches W. 25; L. 38; C. 34
Collection: Rosalind Birnie Philip (L. 405)
Way edition: 22 proofs; published in the
Whirlwind, October 25, 1890;
reprinted by Goulding*

This elegant portrait of Ethel Birnie Philip
was reprinted in a large edition from
separate stones for the short lived weekly
edited by Herbert Vivian and Stuart Erskine.
Each of the four lithographs that appeared
in the *Whirlwind* and *Albemarle* was
subtitled "A Song on Stone." Another
portrait of Ethel Birnie Philip, surely
drawn at the same time, is seen in No. 67.

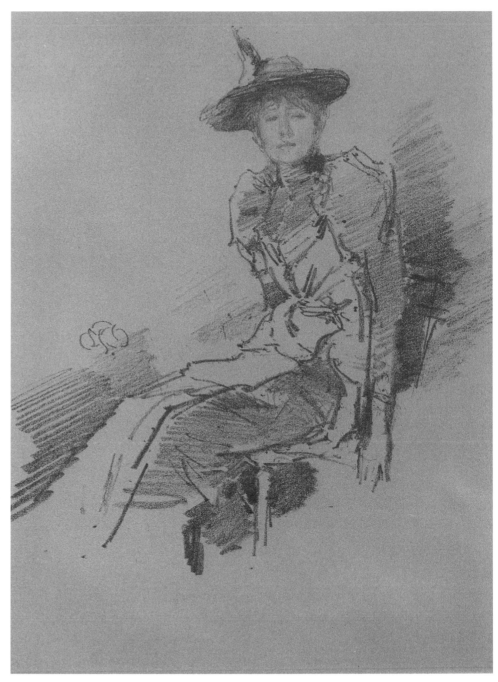

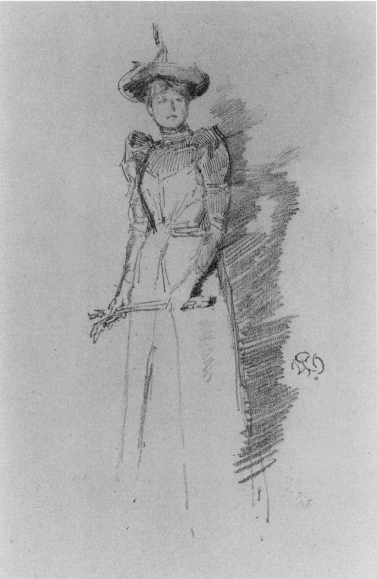

67. *Gants de suede* 1890
Printed on laid Dutch paper, watermarked with crowned shield with
posthorn and D. & C. Blauw
8 1/2 x 4 inches W. 26; L. 40; C. 35
Collection: Rosalind Birnie Philip (L. 405)
Way edition: 28 proofs; published in the *Studio,* 1894;
reprinted by Goulding*

68. *Trixie* ca. 1892–1894
Printed on laid paper with partial watermark and faded ink inscription on verso
7 1/4 x 3 7/8 inches Not in Way; L. 64; C. 80
Edition printed by Goulding in 1903

Whistler's portrait of his wife was drawn directly on the stone in Paris,
thus reversing the butterfly, and put aside until a small edition was pulled
posthumously by Goulding.

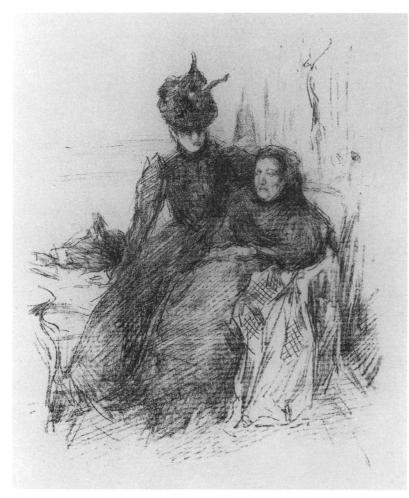

69. _Mother and Daughter_ 1894
Printed on loose china paper
7 3/4 x 6 1/2 inches Not in Way; L. 77; C. 174
Edition: unknown number; printed in Paris by Lemercier or Clot

This image was undoubtedly drawn in Paris on _paper vegetal_ laid over a textured surface. Clot printed _Afternoon Tea_ for Vollard in 1897 and may have transferred this image as well; however, the printer was probably Lermercier.

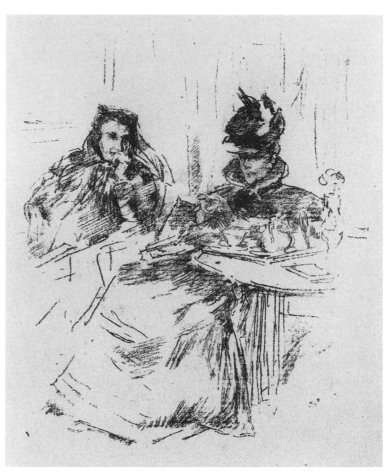

70. _Afternoon Tea_ 1895
Printed on chine volant
7 1/2 x 5 1/2 inches W. 147; L. 114; C. 175
Edition: not given by Way; published by Vollard as _"La Conversation"_ in 1897 in _L'Album d'estampes originales de la Galerie Vollard_ (100 numbered impressions)

Although Way dates the subject to 1895, it was probably executed in 1893 or 1894, and was drawn on thin _papier vegetal_ laid over a textured surface. The drawing was transferred in Paris, possibly by Lermercier, and a few proofs were undoubtedly pulled then. In 1897, it was printed by Auguste Clot on japan paper for publication by Ambroise Vollard. Birnie Philip was unable to locate the stone in Paris; it was presumably destroyed after the printing for Vollard.

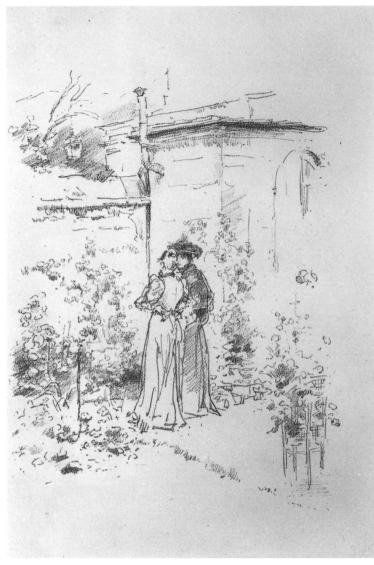

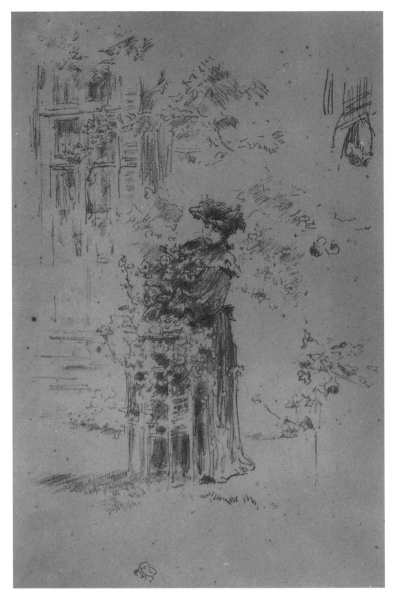

71. *Confidences in the Garden* 1894
Printed on thin laid japan paper, signed in pencil
5 3/8 x 6 3/8 inches W. 60; L. 91; C. 100
Collection: Rosalind Birnie Philip (L. 406)
Way edition: 28 proofs; reprinted by Goulding

Beatrix Whistler and her younger sister, Ethel, are shown talking together
in the garden of the Whistler apartment at 110 rue du Bac. The image at right
shows another view of Trixie in the Whistler's garden in Paris.

72. *La belle jardinière* 1894
Printed on fine old laid paper, signed in pencil
8 7/8 x 6 1/4 inches W. 63; L. 94; C. 101
Collection: Rosalind Birnie Philip (L. 406)
Way edition: 25 proofs, reprinted by Goulding

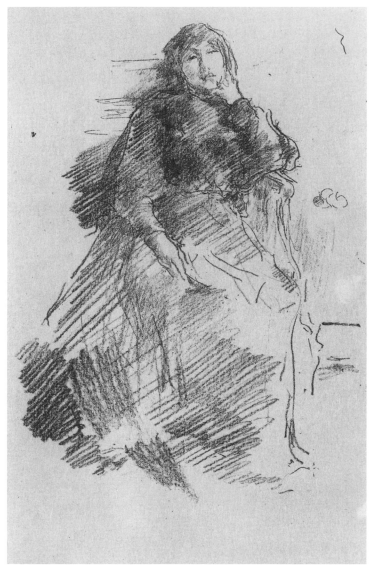

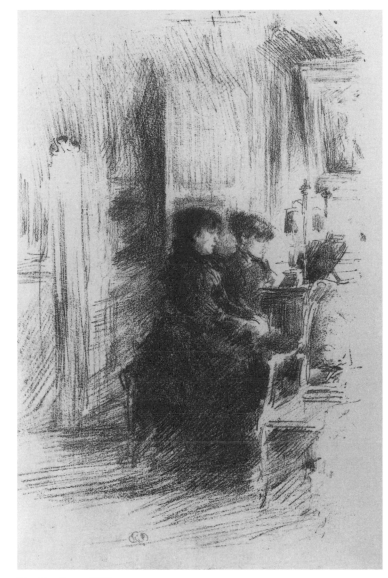

73. **La belle dame, paresseuse** 1894
Printed on heavy laid japan paper, signed in pencil
9 1/4 x 6 3/4 inches W. 62; L. 93; C. 98
Collection: Rosalind Birnie Philip (L. 406)
Way edition: 28 proofs; reprinted by Goulding

By late 1894 Whistler was experimenting continually with new papers
and chalks hoping that his beleaguered printers would succeed in
transferring the drawings to stone. He was particularly pleased when
proofs of this image, a drawing of Trixie, were sent back from London.

74. **The Duet** 1894
Printed on fine laid paper, signed in pencil
9 5/8 x 6 3/8 W. 64; L. 95; C. 104
Collection: Rosalind Birnie Philip (L. 406)
Way edition: 39 proofs; reprinted by Goulding

This drawing depicts Mrs. Whistler and her sister. What interests Whistler is
the way in which the two forms are united in the gathering dark. The drawing
was done on one of the French transfer papers with which Whistler was exper-
imenting. He worked with massed crosshatching to build up value contrasts.

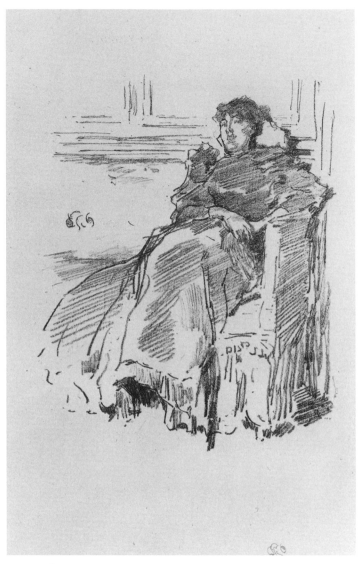

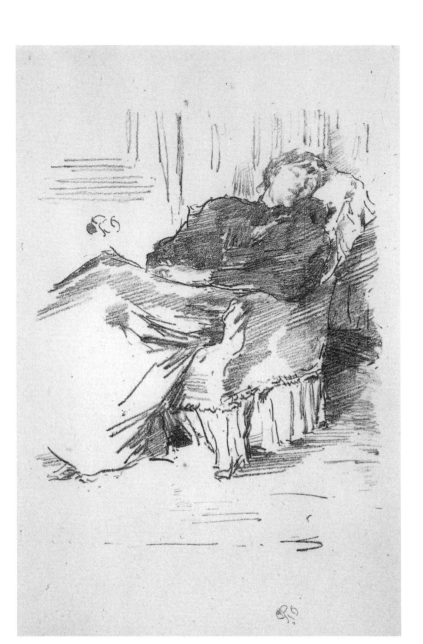

75. *La robe rouge* 1894
Printed on fine old paper from a book with letters watermarked HN,
signed in pencil
7 3/8 x 6 inches W. 68; L. 96; C. 107
Way edition: 23 proofs; published in the *Studio*;
reprinted from the original stone by Goulding

In *Memories* Way confirms that this is a portrait of Trixie drawn in the
Paris apartment in 1894. Local color is suggested by his handling of
the drawing chalk.

76. *La belle dame endormie* 1894
Printed on fine old laid paper with letters watermarked HN, signed in pencil
7 3/4 x 6 1/8 inches W. 69; L. 97; C. 108
Way edition: 42 proofs

Whistler wrote of this portrait of his wife to T. R. Way: ". . . and as to the Sleeping
Lady, . . . like it beyond any lithograph I have done—I do!"

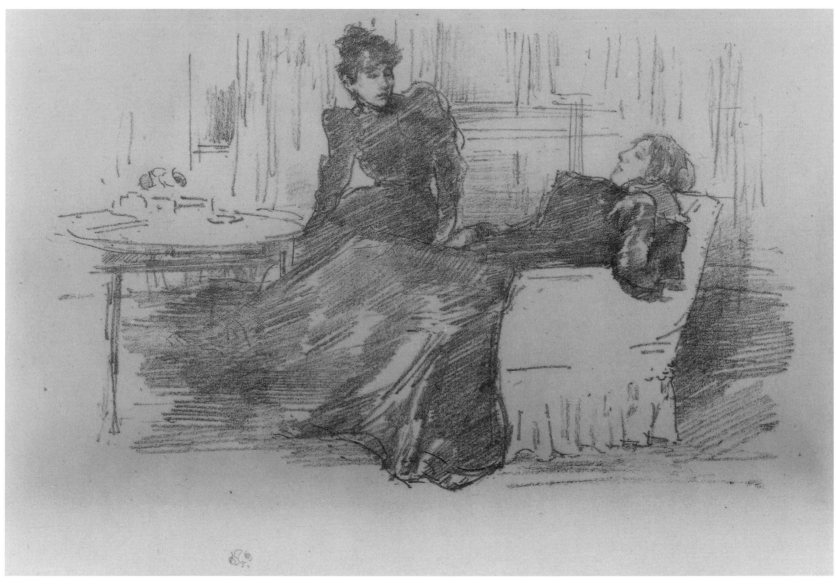

77. *The Sisters* 1894
Printed on fine laid paper, signed in pencil
5 7/8 x 9 W. 71; L. 106; C. 109
Collection: Rosalind Birnie Philip (L. 406). Way edition: 50 proofs

Way describes an earlier state of this lithograph in which there were problems with tonal balance. Apparently the balance was corrected with a scraper, resulting in the image seen here. The sitters are Beatrix Whistler in the armchair and her sister Ethel.

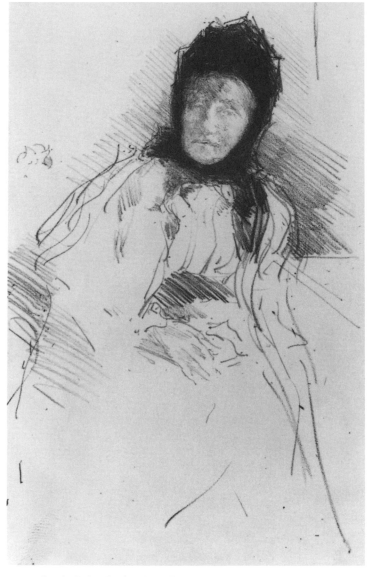

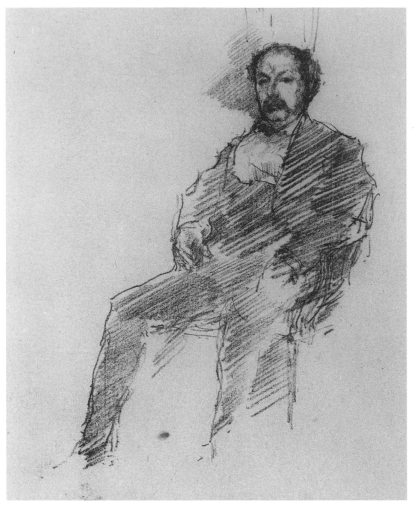

79. **The Doctor** 1894 (dated 1895 in Way's catalogue)
Printed on laid paper with Strasbourg Lily watermark
7 x 5 inches W. 78; L. 117; C. 110
Way edition: 33 proofs; published in *Pageant* in 1896

Whistler's brother William sat for this and another portrait (W. 142).

78. *Unfinished Sketch of Lady Haden* 1895
Printed on thin china paper
11 7/8 x 7 3/4 inches W. 143; L. 139; C. 116
Collection: E. D. Balken (L. 843). Way edition: 2nd state, 4 proofs

This sketch of Whistler's half-sister is one of several drawings executed
directly on stone in 1895. Note that the telltale butterfly prints in reverse.
Whistler did not complete the lithograph to his own satisfaction and
had Way "wipe out at once" the stone after only six proofs were pulled.

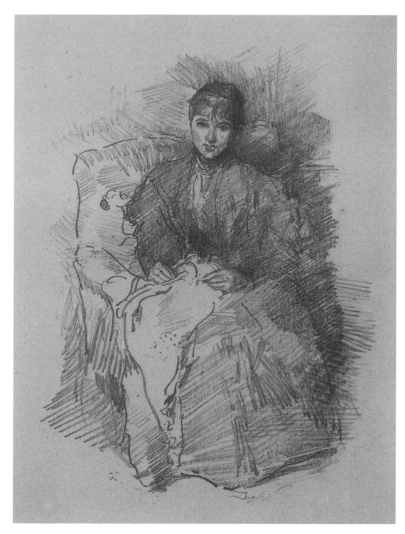

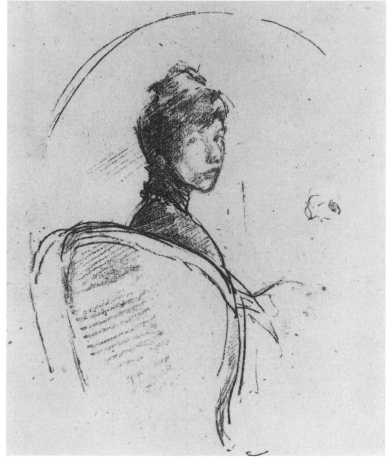

81. *Portrait Study: Miss Rosalind Birnie Philip* 1900–1903
Printed on antique laid paper with old inscription in ink on verso
5 3/8 x 3 7/8 inches Not in Way; L. 189; C. 165
Edition: printed by Goulding in 1903

This is probably *Portrait Study: Oval* mentioned in Birnie Philip's ledger. If so, it is another of the "untried transfers" put on stone and first printed in a small edition by Goulding.

80. *Needlework* 1896
Printed on antique laid paper with foolscap watermark
7 5/8 x 5 5/8 inches W. 113; L. 161; C. 149
Collection: Rosalind Birnie Philip (L. 105)
Way edition: 15 proofs, reprinted by Goulding*

Drawn in soft chalk with vigorous crosshatched shadows, this portrait of Rosalind Birnie Philip was transferred to the stone and may have been drawn on the improved paper the Ways found for Whistler toward the end of his stay in Lyme Regis.

" . . . *the evening mist clothes the riverside with poetry, as with a veil, and the poor buildings lose themselves in the dim sky, and the tall chimneys become campanili, and the warehouses are palaces in the night, the whole city hangs in the heavens . . .*"

James McNeill Whistler
from "The Ten O'clock Lecture"

The Thames and Its Bridges

Views of the Thames and its bridges mark both the beginning of Whistler's career in lithography and its final chapter. The first in 1878 were evocative tonal harmonies of the river at dusk or daybreak as well as images of the old wooden Battersea Bridge that was slated for demolition.

Eighteen years later, during the final stages of Beatrix's fatal illness, the Whistlers spent two months at the Savoy Hotel in a suite overlooking the river. The artist had returned to the Thames. As Whistler looked upriver and down from their balcony, he drew studies on transfer paper of the bridges crossing the Thames. They are atmospheric vignettes of sky, water, carriages passing on the embankment below, and boats moving on the water between well-known buildings lining the near and far shores.

The Ways prepared another stone for Whistler to use to paint once again—after almost two decades—in lithotint washes. The single image he completed, titled simply *The Thames,* stands today as one of the most profoundly poetic and beautiful works of 19th century art. Both the second and third states of *The Thames* are part of the Block Collection (nos. 86 and 87). In the second state, the plumes of smoke and details on the river and riverbank are quite evident; the version is printed with a silver tonality. For the third state, Whistler further scraped and softened the detail to reveal reflections in the river and a more golden and glistening hue.

82. **Savoy Pigeons** 1896
Lithograph on fine laid paper watermarked D. & C. Blauw
7 3/4 x 5 3/8 inches W. 118; L. 164; C. 154
Way edition: 23 proofs; published in the *Studio*;
reprinted by Goulding*

The view Beatrix Whistler saw from her bed looking
across the balcony of the Savoy Hotel to the Thames.

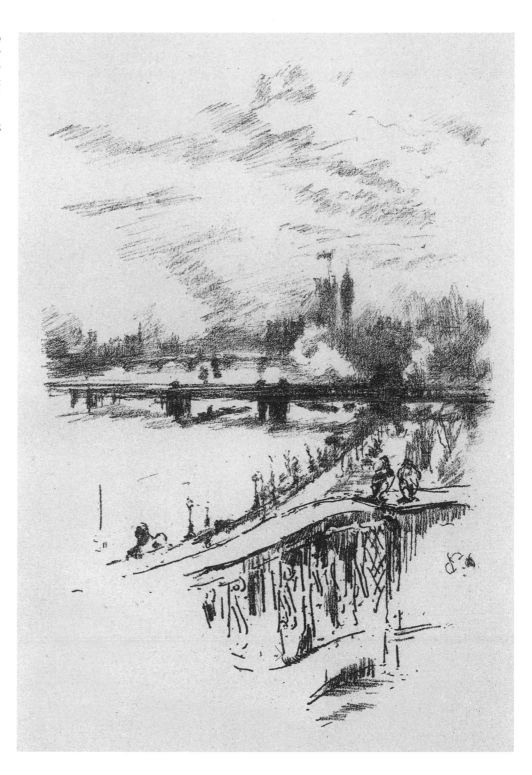

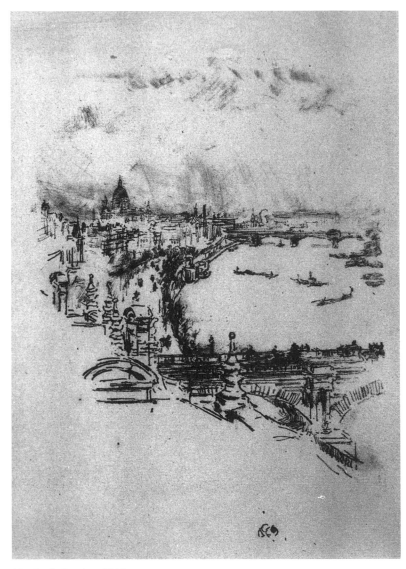

83. *Little London* 1896
Printed on fine laid paper with partial watermark
I HONIG ZOON below GR
7 3/8 x 5 3/8 inches W. 121; L. 173; C. 158
Way edition: 30 Proofs; reprinted by Goulding

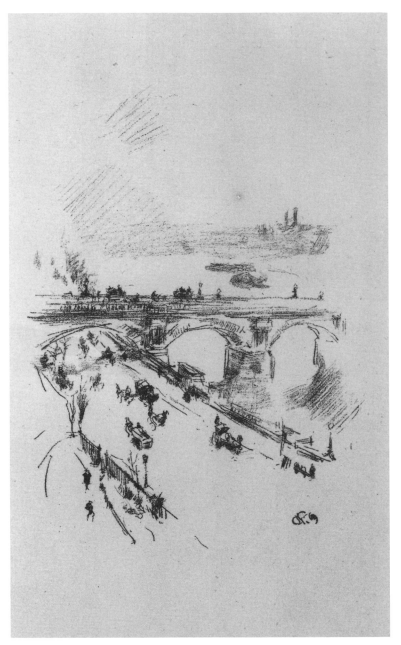

84. *Waterloo Bridge* 1896
Printed on laid paper watermarked D. & G. Blauw
below crowned shield with posthorn
6 5/8 x 5 inches W. 123; L. 177; C. 156
Way edition: 26 proofs; reprinted by Goulding*

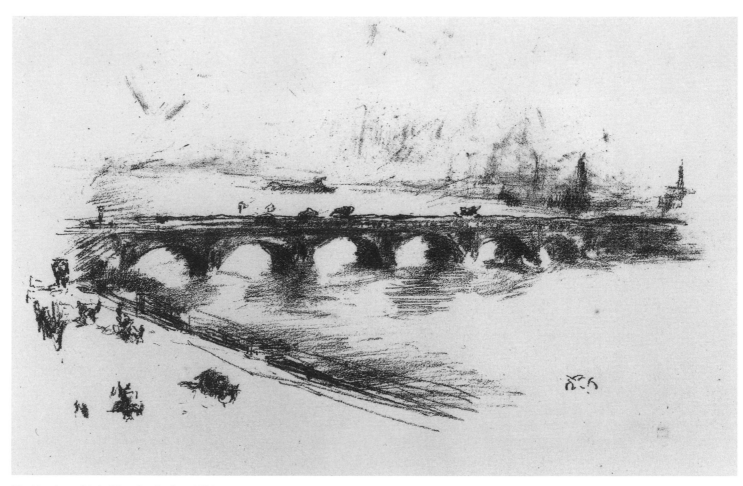

85. *Evening – Little Waterloo Bridge* 1896
Printed on fine laid paper with partial watermark of crowned shield
4 3/4 x 7 1/2 inches W. 119; L. 165; C. 155
Way edition: 26 proofs; reprinted Goulding*

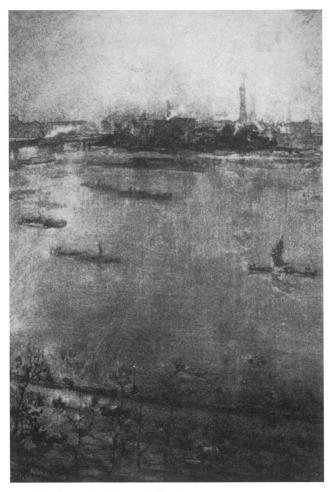

86. *The Thames* (2nd state of 3) 1896
Lithotint on china paper laid down on white wove, signed in pencil
10 1/2 x 7 3/8 inches W. 125b; L. 180; C. 161
Way edition: 10 proofs

After a hiatus of eight years, Whistler produced another lithotint,
a process which required the assistance of the Ways. Once again he
worked with wash and scraper on a stone prepared with half-tint.
The result, after at least two reworkings, was one of his most beau-
tiful nocturnes. Apparently there were problems with the tonal
balance when the first proofs were printed. The impression, one of
only ten recorded of the second state, was pulled after corrections
were done.

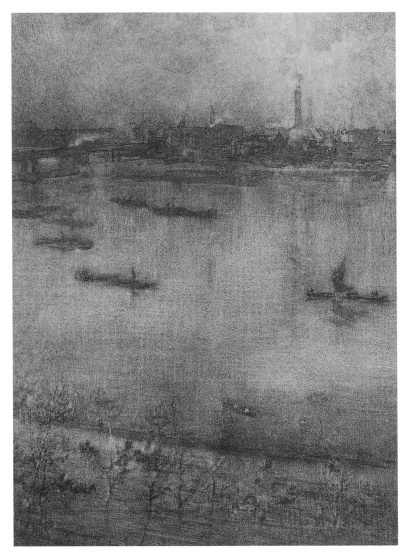

87. *The Thames* (3rd state of 3) 1896
Lithotint on cream laid paper with O.W. P. and A.C.L. watermark
10 1/2 X 7 3/8 inches W. 125; L. 178; C. 161
Way edition: 12 proofs; reprinted by Goulding (1903–04)*

The third state of *The Thames* has been scraped and re-etched. T. R. Way asked
permission to have H. Bray, his finest printer, pull additional proofs realizing
that it was one of the artist's most remarkable works. Whistler refused. However,
the stone was printed posthumously by Goulding with the assistance of Charles
Lang Freer who lent his lifetime proofs as models.

Bibliography

Art Institute of Chicago. *The Lithographs of James McNeill Whistler*, 2 vols. (Volume 1: Catalogue Raisonné; Volume II: Correspondence and Technical Studies) Chicago, 1998.

Bacher, Otto. "Stories of Whistler." *Century Magazine* 74 (May 1907): 110-111.

_____ . "With Whistler in Venice, 1880-1886." *Century Magazine* 73 (December 1906): 207-18.

Cary, Elizabeth Luther. "Whistler's Lithographs." *Scrip* 1 (December 1905): 70-74.

Chase, William Merritt. "The Two Whistlers—Recollections of a Summer with the Great Etcher." *Century Magazine* 80 (June 1910): 219-26.

Delaney, Paul. "Whistler, Shannon and the Revival of Lithography as Art." *Nineteenth Century* 4 (Winter 1978): 76-80.

Dempsey, Andrew. "Whistler and Sickert: A Friendship and Its End." *Apollo* 83 (January 1966): 30-37.

Dowdeswell, Walter. "Whistler." *Art Journal* 5 (April 1887): 97-103.

Druick, Douglas, and Zegers, Peter. *La Pierre Parle: Lithography in France* 1848-1900. Exhibition Catalogue. Ottawa: National Gallery of Canada, 1981.

[E.G.D.] "The Whistler Lithographs at the Brooklyn Museum." *Brooklyn Museum Quarterly* 2 (April 1915): 219-25.

Fine, Ruth, ed. *James McNeill Whistler: A Reexamination: Studies in the History of Art* 19. Washington, D.C. 1987.

Getscher, Robert H. and Marks, Paul G. *James McNeill Whistler and John Singer Sargent: Two Annotated Bibliographies.* New York and London, 1986.

_____ . *The Stamp of Whistler.* Exhibition Catalogue. Oberlin: Allen Memorial Art Museum, Oberlin College, 1977.

Hartrick, A.S. "Lithography and the Senefelder Club." *Apollo* 1 (April 1925): 203-10.

Hobbs, Susan and Spink, Nesta R. *Lithographs of James McNeill Whistler from the Collection of Steven Louis Block.* Smithsonian Traveling Exhibition Service, Washington, D.C., 1982.

Hom Gallery. *James Abbott McNeill Whistler, A Retrospective Exhibition of the Artist's Lithographs.* Washington, D.C., 1979.

Jackson, Ernest. "Modern Lithography." *Print Collector's Quarterly* 11 (April 1924): 205-26.

Kennedy, E.G. *The Etched Work of Whistler.* Rev. ed., San Francisco, 1978.

_____ . *The Lithographs by Whistler, Arranged According to the Catalogue by Thomas R. Way.* New York: Kennedy and Co., 1914.

Keppel and Co. *Catalogue of an Exhibition of Lithographs by Whistler from the Collection of Thomas R. Way.* New York, January 8 to January 30, 1914.

Keppel, Frederick. *The Gentle Art of Resenting Injuries.* New York: Privately printed, 1904. Copy in the Library of the National Museum of American Art.

Key, Mabel. "Artistic Lithography, Its Present Possibilities." *Brush and Pencil* 5 (October 1899); 31-44.

Knoedler and Co. "Fifty Lithographs by James McNeill Whistler." *Print Collector's Bulletin.* Illustrated Catalogue for Museums and Collectors. New York, 1930.

_____ . *Catalogue of an Exhibition of Lithographs by Whistler.* New York, 1919.

_____ . *Exhibition of Etchings and Lithographs by Whistler.* New York, February 1973.

Levy, Mervyn. *Whistler Lithographs, An Illustrated Catalogue Raisonné.* London: Jupiter Books, 1975.

Lochnan, Katharine A. *The Etchings of James McNeill Whistler,* New Orleans and London, 1984.

_____ . "Whistler and the Transfer Lithograph: A Lithograph with a Verdict." *Print Collector's Newsletter* 12 (November-December 1981): 133-37.

MacDonald, Margaret, F. "Whistler's Lithographs." *Print Quarterly* 5, no. 1 (March 1988): 20-55.

_____ . *James McNeill Whistler: Drawings, Pastels, and Watercolors. A Catalogue Raisonné,* New Haven and London, 1980.

_____ . *Whistler, The Graphic Work: Amsterdam, Liverpool, London, Venice.* London: Arts Council of Great Britain, 1976.

Pennell, Elizabeth Robbins. "The Master of the Lithograph—J. McNeill Whistler." *Scribner's Magazine* 21 (March 1897): 277-89.

Pennell, Joseph and Robbins, Elizabeth. *Lithography and Lithographers,* 1898. Reprint. New York: MacMillan & Co., 1915.

_____ . *The Life of James McNeill Whistler.* 2 Volumes: London: William Heinemann; Philadelphia: J.B. Lippincott Company: 1908, 1911, and 1920.

_____ . *The Whistler Journal.* J.B. Lippincott Company, Philadelphia, 1921.

Pennell, Joseph. "Evelyn, an Original Lithograph by James McNeill Whistler." *Art Journal* 58 (March 1896): 89.

_____ . "Lithography." *Print Collector's Quarterly* 2 (December 1912): 452-82.

_____ . "The Senefelder Club and the Revival of Artistic Lithography." *Studio* 52 (March 1914): 3-20.

_____ . "The Triumph of Whistler." *Bookman* 43 (October 1912): 19-30.

_____ . "The Truth About Lithography." *International Studio* 16 (March 1899): 38-44.

_____ . Whistler as Etcher and Lithographer." *Burlington Magazine* 3 (November 1903). 160-68.

Rothenstein, William. "Some Remarks on Artistic Lithography." *International Studio* 3 (April 1894): 16-17.

Sandberg, John. "Whistler's Early Work in America 1834-1855." *Art Quarterly* 29 (Spring 1966): 46-59.

Smale, Nicholas. "Whistler and Transfer Lithography," *The Tamarind Papers* 7, no. 2 (Fall 1984): 72-83

Stein, Donna M. and Karshan, Donald H. *L'Estampe Originale, A Catalogue Raisonné.* New York: Museum of Graphic Arts, 1970.

Way, T.R. *Memories of James McNeill Whistler, the Artist.* London and New York: John Lane Co., 1912.

_____ . "Mr. Whistler as a Lithographer." *International Studio* 21 (November 1903): 10-21.

_____ . "Mr. Whistler's Lithographs." *International Studio* 6 (January 1896): 219-27.

_____ . "Some Remarks on Artistic Lithography." *International Studio* 3 (April 1894): 18.

_____ . "Whistler's Lithographs." *Print Collector's Quarterly* 3 (October 1913): 227-309.

_____ . *Mr. Whistler's Lithographs, The Catalogue Compiled by Thomas R. Way.* London: George Bell and Sons, 1896.

_____ . *Mr. Whistler's Lithographs, The Catalogue Compiled by Thomas R. Way.* London: George Bell and Sons, Second Edition, 1908.

Way, T.R. and Dennis, G.R. *The Art of James McNeill Whistler, an Appreciation.* London: George Bell and Sons, 1905.

Weber, Wilhelm, *A History of Lithography.* London: Thames and Hudson, 1966.

Wedmore, Frederick. "The Revival of Lithography." *Art Journal* 58. (January 1896): 11-13.

Whistler, James Abbott McNeill. *The Gentle Art of Making Enemies.* 2nd ed. London and New York: 1892 (Dover Publications reprint 1967).

Young, Andrew McLaren, MacDonald, Margaret F., Spencer, Robin and Miles, Hamish. *The Paintings of James McNeill Whistler.* 2 Volumes. New Haven and London, 1980.

Young, Andrew McLaren. *James McNeill Whistler.* Exhibition catalogue. London: Arts Council of Great Britain, 1960.